MANGA ARTISTS'

BEGINNER'S GUIDE TO

ALCOHOL MARKERS

Manga Artists' Beginner's Guide to Alcohol Markers
First Published in 2023 by Zakka Workshop, a division of World Book Media LLC

www.zakkaworkshop.com
134 Federal Street
Salem, MA 01970
info@zakkaworkshop.com

SERIA NO ILLUSTO-YO ALCOHOL MARKER NIRI-KATA BOOK
©2020 Boutique-Sha
All Rights Reserved
Title originally published in Japanese language by Boutique-Sha, Tokyo, Japan
English language rights, translation & production by World Book Media LLC

Publisher: Satoru Shimura
Editor: Noriaki Sakabe & Tomoya Kashiwakura (STUDIO PORTO)
Production Cooperation: Seria Co., Ltd.
Design: Jeong Jae-in (STUDIO DUNK)
Photography: Yuki Miwa (STUDIO DUNK)

English editor: Lindsay Fair
Translator: Mayumi Anzai

ISBN: 978-1-940552-76-7

Printed in China

10 9 8 7 6 5 4 3 2 1

MANGA ARTISTS'

BEGINNER'S GUIDE TO

ALCOHOL MARKERS

KARIN

Learn to Layer, Mix and Blend Colors for Awesome Anime Art!

CONTENTS

GETTING STARTED WITH ALCOHOL MARKERS...7

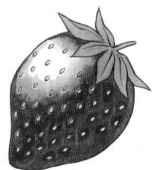

LET'S COLOR A CHARACTER IN A SAILOR OUTFIT...26

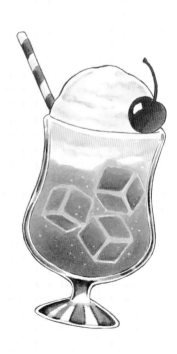

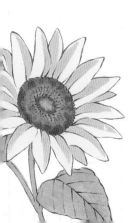

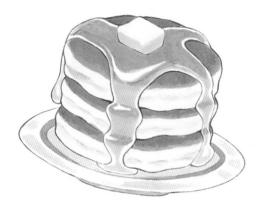

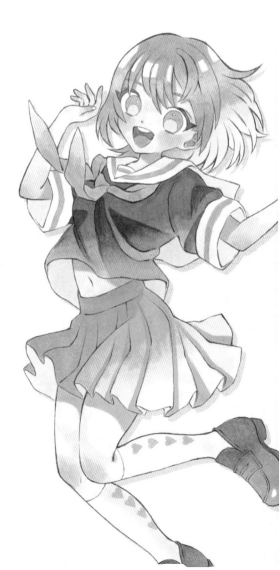

INTRODUCTION

Hi There! I'm Karin.

I'm a manga artist from Japan who loves to color using alcohol markers.

I created this book for beginners who are interested in learning how to use these special markers. First, we'll explore the basics of working with alcohol markers, and then we'll apply these techniques by coloring fun manga characters and everyday objects from start to finish.

There are even black and white line drawings printed on heavyweight paper at the back of the book, so once you've mastered the basics, you can practice coloring with alcohol markers.

I hope you enjoy this book and that it teaches you how to use alcohol markers to add vibrant colors and beautiful dimension to your artwork.

Karin

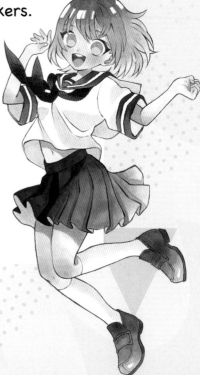

GETTING STARTED WITH ALCOHOL MARKERS

Before we get started coloring, let's learn how to use alcohol markers. We'll start with the basics, and then discuss more advanced techniques, like layering, mixing and blending colors. These techniques will help you take your artwork to the next level!

WHAT ARE ALCOHOL MARKERS?

There are two main types of markers: water-based and alcohol-based. These terms refer to the type of ink inside the marker. With water-based markers, the color is suspended in water, while with alcohol-based markers, the color is suspended in alcohol. When you use a marker, the water or alcohol eventually dries, leaving the color behind on the page.

If you've ever colored with Crayola markers before, you're already familiar with water-based markers. In addition to the inexpensive, widely available sets with washable ink designed for school kids, you'll also find high quality water-based markers made specifically for professional artists. Water-based markers don't bleed through paper very much, making them a great option for coloring books and journals; however, they can be streaky and difficult to blend.

Alcohol markers are often preferred by artists because they blend more smoothly and can be used to create subtle layering and shading effects. Also known as permanent ink, alcohol markers dry quickly; however, they can bleed through the paper, so it's always a good idea to put a piece of scrap paper behind the page you're working on to prevent damaging your work surface or other pages. Alcohol markers are available in a wide array of colors and are sold in art supply stores and online. They tend to be more expensive than water-based markers, but are a great long-term investment for artists who plan to do a lot of coloring.

SELECTING YOUR ALCOHOL MARKERS

There are several different brands of alcohol markers available on the market today. Everyone has their own personal preferences about what qualities make one marker better than another, so we've compiled a list of factors for you to consider when shopping for alcohol markers:

Price

Alcohol markers range in price from less than $1 to over $7 per marker. If you purchase markers as a set, this usually brings the individual cost per marker down.

Color Range

Some brands offer over 300 different colors, while others have fewer options.

Availability

You can purchase the more expensive, well-known brands at art supply stores, as well as store brand versions of alcohol markers. Many of the less expensive alcohol markers are available for purchase online only.

Single Markers vs Sets

Some brands allow you to purchase markers individually, which is great if you run out of one color faster than the others, or if you want to purchase specific colors for a project.

Refillable

Some of the more expensive brands of alcohol markers are refillable, which means you can add ink to the marker body when it runs out rather than buying a whole new marker. This cuts down on waste and is more cost effective in the long run.

Nib Style

Most alcohol markers are dual-tipped and come with a brush tip on one end and a chisel tip on the other (see page 12 for more info). However, some of the cheaper markers feature a bullet tip rather than a brush tip. Brush tips are generally preferred for coloring.

Colorless Blender

Many brands of alcohol markers offer a colorless blender, which is a clear marker that can be used to clean up mistakes, add highlights, and create faded and blended effects. See page 19 for more info on working with colorless blenders.

We recommend testing out a few different brands of alcohol markers to find your favorite. When testing markers, here are some things to consider:

Swatch

How do the colors look when you try them out? Are they vibrant or dull?

Smudge

Does the ink smear or smudge? Perform this test by using a light color alcohol marker on top of the outline pen you plan to use on your drawing as alcohol markers can smudge other inks. See page 15 for more info on selecting an outline pen.

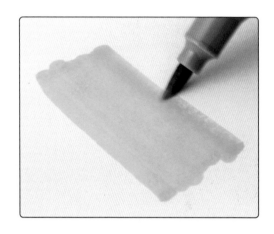

Layer

How do the colors look when you layer multiple coats on top of each other? Is there variation from light to dark?

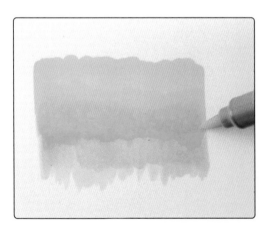

Blend

Do the colors blend well? Alcohol markers should blend smoothly from one color to another. To perform this test, make a rainbow swatch with a red, yellow, and blue marker, blending the colors where they overlap to create orange, green, and purple in between.

Bleed

Does the ink bleed through the page? Most alcohol markers will bleed through, but this will be more pronounced with some brands, especially the more expensive ones which have more vibrant pigments.

THE 36 ALCOHOL MARKER COLORS
USED IN THIS BOOK

There are a lot of really nice alcohol markers out there, but if you are just getting started, you can still achieve great results from a small assortment of affordable markers. The illustrations in this book were created using 36 different colors. The following guide shows the colors that were used so you can find similar shades in whatever brand of alcohol markers you're using. You'll also want to have a mechanical pencil and a white gel pen on hand.

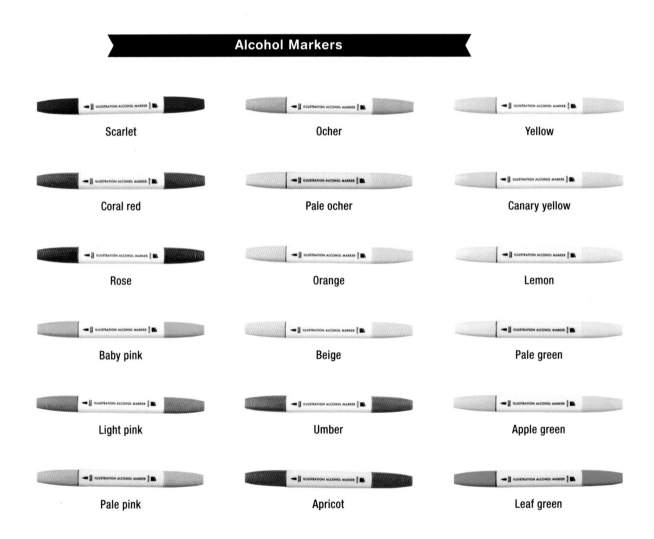

Alcohol Markers

Scarlet	Ocher	Yellow
Coral red	Pale ocher	Canary yellow
Rose	Orange	Lemon
Baby pink	Beige	Pale green
Light pink	Umber	Apple green
Pale pink	Apricot	Leaf green

Other Tools You'll Need

Mechanical pencil White pen

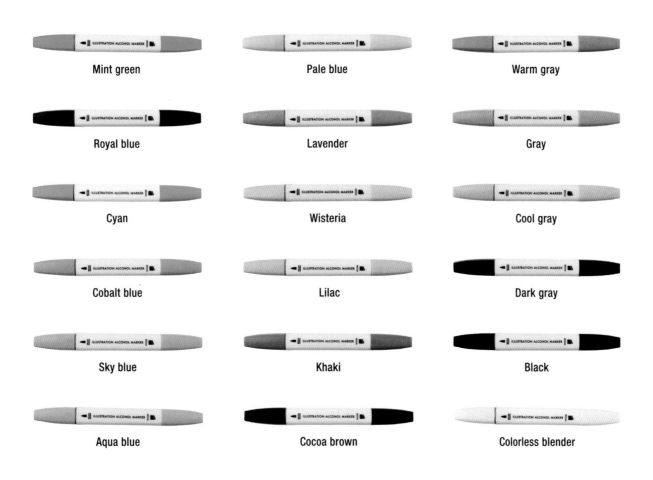

Mint green	Pale blue	Warm gray
Royal blue	Lavender	Gray
Cyan	Wisteria	Cool gray
Cobalt blue	Lilac	Dark gray
Sky blue	Khaki	Black
Aqua blue	Cocoa brown	Colorless blender

See page 19 for more information on using a colorless blender marker.

ALCOHOL MARKER BASICS

Most alcohol markers have two different tips, a brush tip and a chisel tip.
Let's look at the tips more closely and learn the advantages of using each type.

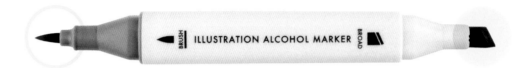

Brush Tip

The brush tip has a soft nib that moves smoothly and evenly across the page.

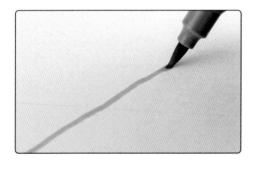

Thin line

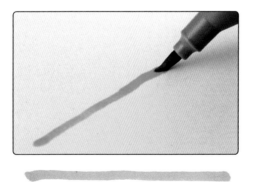

Thick line

Chisel Tip

The chisel tip has a firm nib, which is great for writing text. When coloring, the chisel tip tends to produce an unevenness in shade, which can be used intentionally to express texture.

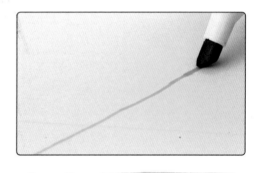

Thin line

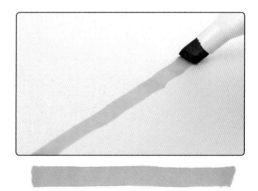

Thick line

How to Fill a Large Area

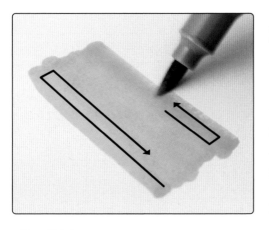
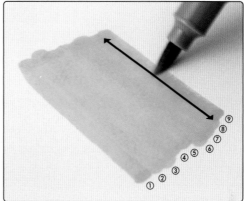

The trick is to lay the marker tip down so it's parallel to the paper, and then move it back and forth across the page, both horizontally and vertically. It's necessary to reapply several times to achieve beautiful, even results.

How to Use the Brush Tip

Taper Off

Use a quick flicking motion as you release the marker tip from the paper.

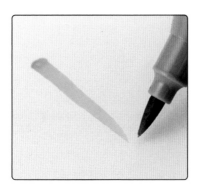

Stop

Lightly press the marker tip against the paper as you stop coloring.

OTHER TOOLS & MATERIALS

When working with alcohol markers, there are two other important materials you'll need to consider: paper and outline pen.

Paper

When selecting paper to use with alcohol markers, it's important to consider the paper's texture and thickness because these elements can influence ink absorption and color bleeding. Let's examine different types of paper and see how they hold up to alcohol markers.

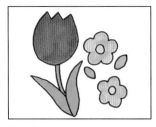

Sample

Bleed

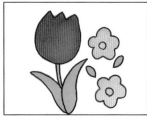

Sample

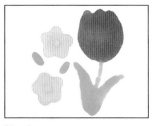

Bleed

Kent Paper

Kent paper has a smooth surface and does not bleed easily, so it works well with alcohol markers. This paper is thick, so the ink will not show through on the reverse side quite as much as other papers.

Drawing Paper

Thick and with a rough texture, this paper absorbs ink well and bleeding is relatively modest.

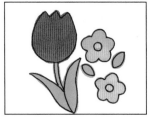

Sample

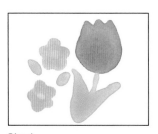

Bleed

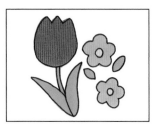

Sample

Bleed

Sketchbook

This paper absorbs the ink well, but the colors bleed and show through easily on the reverse side of the paper.

Copy Paper

This type of paper is very thin, so the colors show through easily on the reverse side. Make sure to protect your work surface when using this type of paper.

Outline Pen

Outlining your art is an important part of manga illustration, especially when working with alcohol markers. You'll want to be careful when selecting an outline pen, as certain types are more likely to smear. The following guide shows the test results of combining common outline pens with alcohol marker.

Does Not Smear

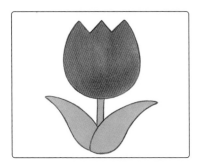

Drawing Pen

A Marvy Uchida Le Pen drawing pen was used to create the outlines for the illustrations in this book.

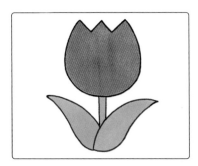

Water-Based Ballpoint Pen

Available water-based ballpoint pens include the Pentel B100-AD and the Pilot Hi-Tecpoint.

Gel Ink Ballpoint Pen

This sample was done with a Pilot Hi-Tec-C black pen. Please note that ink colors other than black tend to smear.

Smears Easily

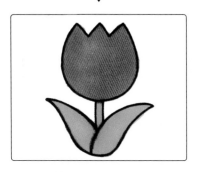

Oil-Based Pen

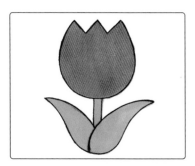

Oil-Based Ballpoint Pen

Pencil

ALCOHOL MARKER COLORING TECHNIQUES

Now that we've covered the basics, let's move on to some more advanced coloring techniques using alcohol markers. We'll learn about layering, blending, blurring, and removing color to create special effects. Once you master these techniques, you can apply them to your own artwork.

Layering

Alcohol markers are sold in a variety of colors, but you can create even more shades by layering.

Layer One Color

Layer two coats of the same color to produce a darker shade.

Layer Two Colors

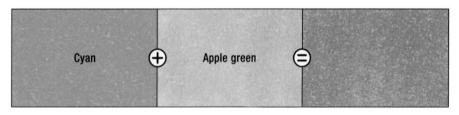

Layer coats of different colors on top of each other to create a new shade.

Layer Colors to Change the Brightness

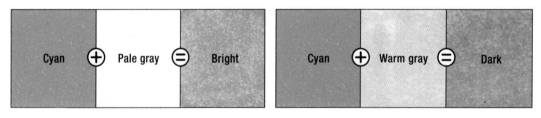

Layer a light gray on top of a color to create a brighter version of that color, or layer a dark gray on top of a color to create a darker version of that color.

See pages 20-22 for inspiration and examples of layering colors.

Blending

Use this technique to transition from dark to light when using one color or to transition from one color to another.

One Color

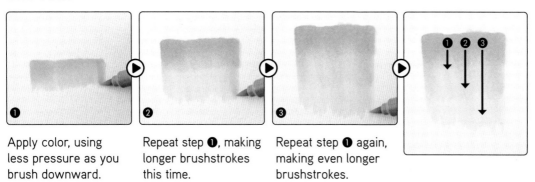

Apply color, using less pressure as you brush downward.

Repeat step ❶, making longer brushstrokes this time.

Repeat step ❶ again, making even longer brushstrokes.

Two Colors

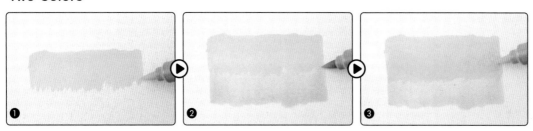

Apply the first color, using less pressure as you brush downward.

Apply the second color, brushing upward so that it overlaps with the color from ❶.

Apply the first color to the overlap area to blend the two colors. Repeat steps ❶-❸ as needed until the colors are well blended.

Three Colors

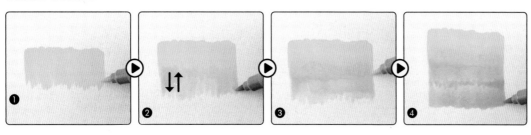

Apply the first color, using less pressure as you brush downward.

Apply the second color by brushing upward and downward.

Apply the first color to the overlap area to blend the two colors.

Apply the third color by brushing upward.

See page 23 for inspiration and examples of blending colors.

Blurring

You can create a soft, fuzzy impression by extending the color beyond its original boundary.

Use a Blender Marker

Use a blender marker to blur the boundaries and create a soft impression.

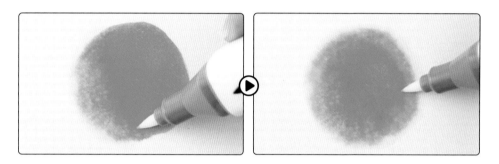

Use a Light Color Marker

Apply a lighter shade in the same color to the edges, making it appear as if the color is bleeding.

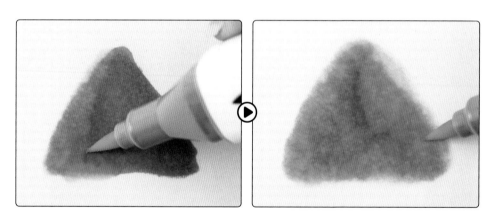

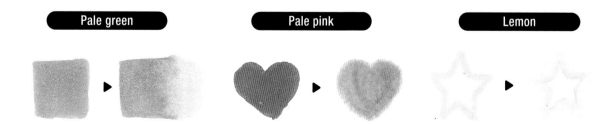

Pale green Pale pink Lemon

Removing Color

Use the special transparent blender marker to correct mistakes or to intentionally remove color from areas of your work. Make sure to place a sheet of paper underneath your work when using a blender marker.

Correction

Apply the blender marker to areas where you've colored outside the lines. It won't remove the color completely, but it will lighten it so it's less visible.

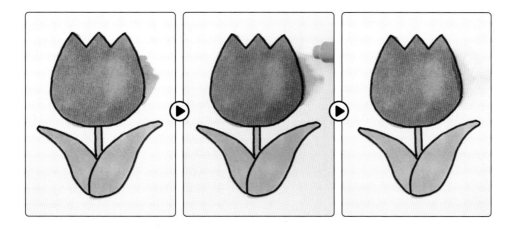

Removal

Once the first color of marker has dried, use a blender marker on top to remove color in the desired areas. This technique is perfect for creating a highlight.

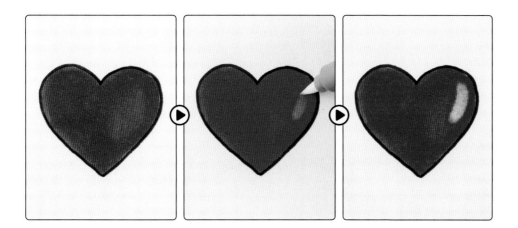

ALCOHOL MARKER COLOR SWATCHING

Before you get started coloring, it's a good idea to try out some of the techniques that you'll want to incorporate into your work. The best way to do this is to make swatches to test out how your colors will look when layered, mixed, and blended.

Layering Color

Let's take a closer look at layering multiple coats of a single color. The following key includes the 36 different colors used for the illustrations in this book. The swatches show how the color looks with a first coat, second coat, and third coat. Look closely to compare the variation among different colors.

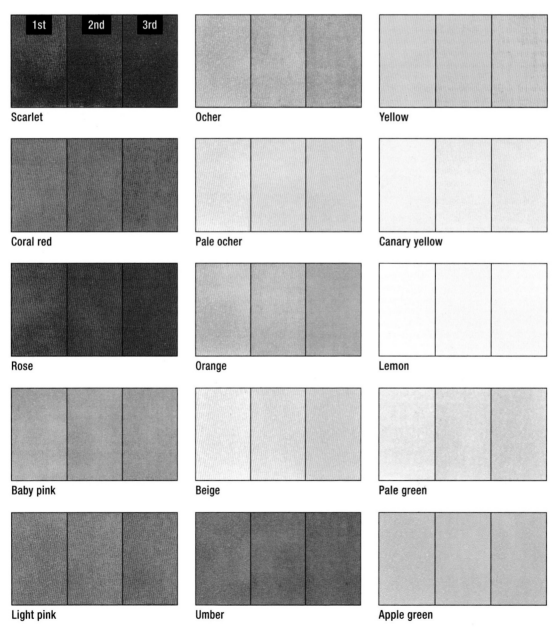

Scarlet	Ocher	Yellow
Coral red	Pale ocher	Canary yellow
Rose	Orange	Lemon
Baby pink	Beige	Pale green
Light pink	Umber	Apple green

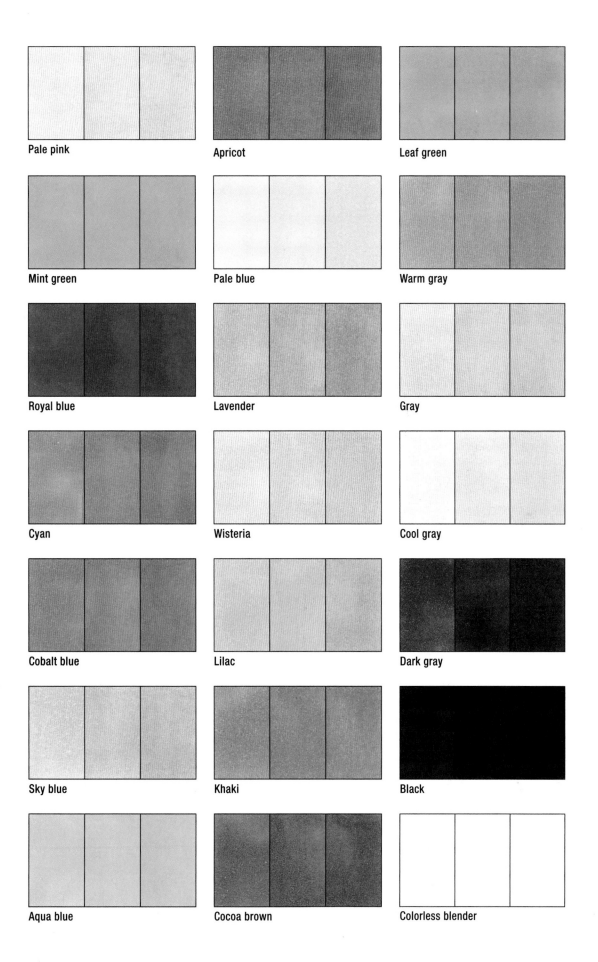

Pale pink

Apricot

Leaf green

Mint green

Pale blue

Warm gray

Royal blue

Lavender

Gray

Cyan

Wisteria

Cool gray

Cobalt blue

Lilac

Dark gray

Sky blue

Khaki

Black

Aqua blue

Cocoa brown

Colorless blender

Mixing Colors

When working with alcohol markers, you are not limited to using the colors you can buy at the store. You can make your own unique shades by layering coats of different colors, also known as mixing colors. This is a great way to add complexity to your art and expand your color palette. Let's take a look at some of the fun colors you can create by mixing.

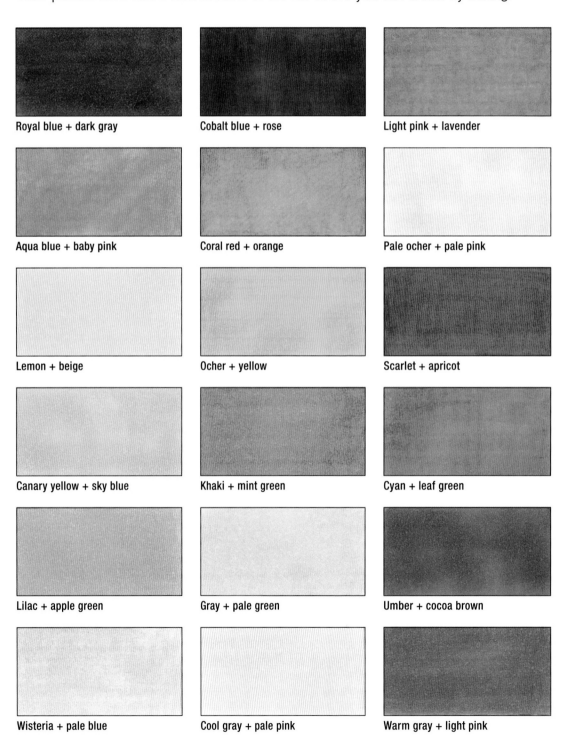

Royal blue + dark gray

Cobalt blue + rose

Light pink + lavender

Aqua blue + baby pink

Coral red + orange

Pale ocher + pale pink

Lemon + beige

Ocher + yellow

Scarlet + apricot

Canary yellow + sky blue

Khaki + mint green

Cyan + leaf green

Lilac + apple green

Gray + pale green

Umber + cocoa brown

Wisteria + pale blue

Cool gray + pale pink

Warm gray + light pink

Blending Colors

Another fun technique you can explore when using alcohol markers involves blending colors. Lay swatches of a few colors down on the page, then go over the areas where the colors overlap to blend them together and create beautiful, subtle shading. Take a look at some of the blended color swatches below for inspiration.

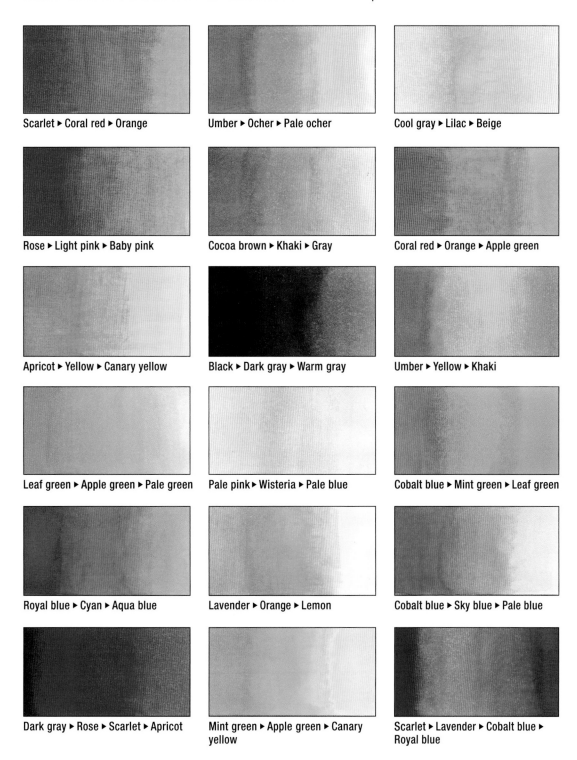

Scarlet ▶ Coral red ▶ Orange

Umber ▶ Ocher ▶ Pale ocher

Cool gray ▶ Lilac ▶ Beige

Rose ▶ Light pink ▶ Baby pink

Cocoa brown ▶ Khaki ▶ Gray

Coral red ▶ Orange ▶ Apple green

Apricot ▶ Yellow ▶ Canary yellow

Black ▶ Dark gray ▶ Warm gray

Umber ▶ Yellow ▶ Khaki

Leaf green ▶ Apple green ▶ Pale green

Pale pink ▶ Wisteria ▶ Pale blue

Cobalt blue ▶ Mint green ▶ Leaf green

Royal blue ▶ Cyan ▶ Aqua blue

Lavender ▶ Orange ▶ Lemon

Cobalt blue ▶ Sky blue ▶ Pale blue

Dark gray ▶ Rose ▶ Scarlet ▶ Apricot

Mint green ▶ Apple green ▶ Canary yellow

Scarlet ▶ Lavender ▶ Cobalt blue ▶ Royal blue

COLORING PATTERNS WITH ALCOHOL MARKERS

Now that you've learned a few different techniques using alcohol markers, let's experiment by drawing some fun, colorful patterns. Incorporate patterns into your manga drawings to create characters with unique personalities.

Plaid

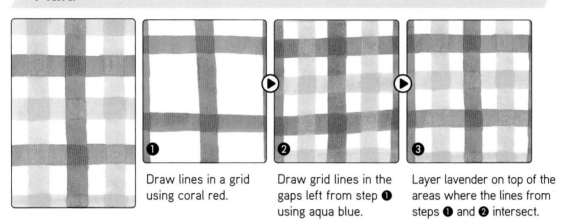

❶ Draw lines in a grid using coral red.

❷ Draw grid lines in the gaps left from step ❶ using aqua blue.

❸ Layer lavender on top of the areas where the lines from steps ❶ and ❷ intersect.

Stripes

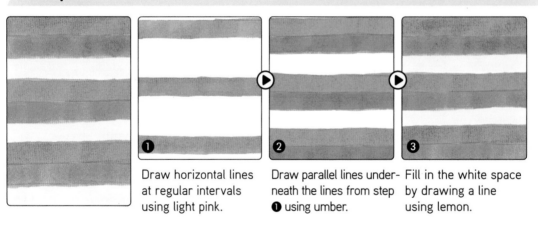

❶ Draw horizontal lines at regular intervals using light pink.

❷ Draw parallel lines underneath the lines from step ❶ using umber.

❸ Fill in the white space by drawing a line using lemon.

Dots

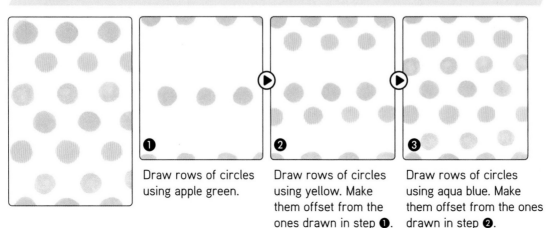

❶ Draw rows of circles using apple green.

❷ Draw rows of circles using yellow. Make them offset from the ones drawn in step ❶.

❸ Draw rows of circles using aqua blue. Make them offset from the ones drawn in step ❷.

Argyle

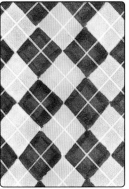

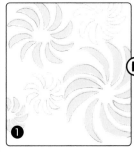 **❶** Draw a diamond pattern, alternating sky blue and yellow.

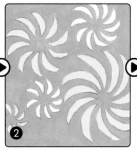 **❷** Fill in the white space using dark gray.

 ❸ Draw diagonal lines using a white pen.

Swirls

 ❶ Draw swirls with wedge-shaped blades. Fill in half of the swirls using canary yellow.

 ❷ Color the background mint green.

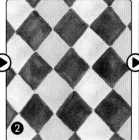 **❸** Apply a coat of apple green on top of the mint green from step ❷.

Checkered

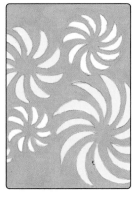

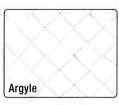 **❶** Draw a checkerboard pattern by coloring alternating squares using aqua blue.

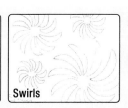 **❷** Color the remaining squares using cyan.

TIP **Let's Sketch a Draft**

For more complicated patterns, it may be helpful to sketch a draft using pencil first.

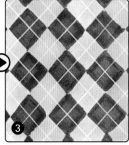

Argyle

Checkered

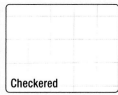 Swirls

LET'S COLOR A CHARACTER IN A SAILOR OUTFIT

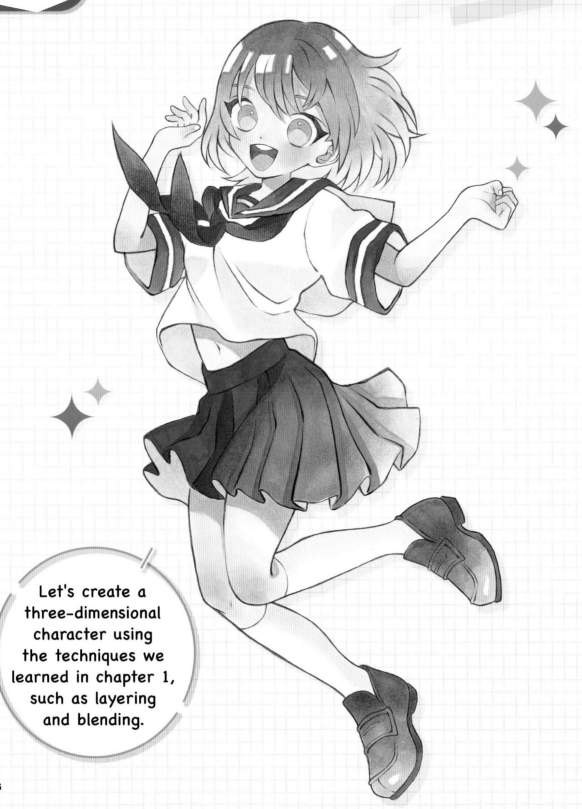

Let's create a three-dimensional character using the techniques we learned in chapter 1, such as layering and blending.

COLOR PLANNING

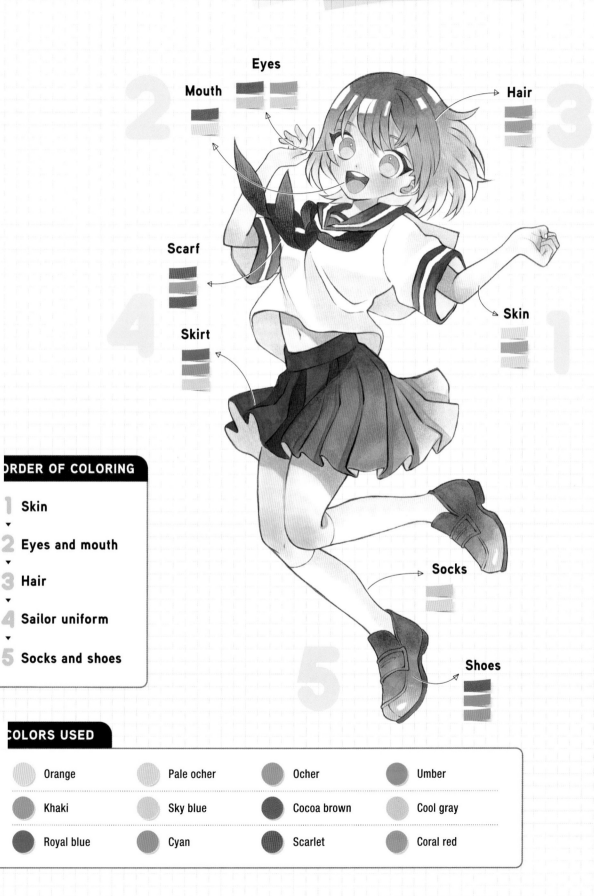

Eyes

Mouth

Hair

Scarf

Skin

Skirt

Socks

Shoes

ORDER OF COLORING

1 Skin

2 Eyes and mouth

3 Hair

4 Sailor uniform

5 Socks and shoes

COLORS USED

Orange	Pale ocher	Ocher	Umber
Khaki	Sky blue	Cocoa brown	Cool gray
Royal blue	Cyan	Scarlet	Coral red

HOW TO COLOR THE SKIN

Just three colors are used to color this character's skin: orange, pale ocher, and ocher. The key is to start coloring in the areas where you want to create a rosy appearance, such as the cheeks, fingers, and joints.

Coloring the Face

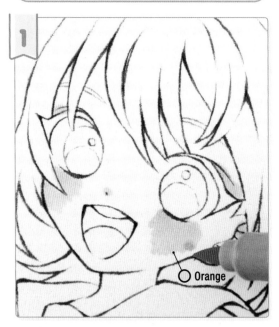

Apply orange to the cheeks, nose, eyelids, and ears. These are the areas of the face where you want to create a rosy, flushed appearance.

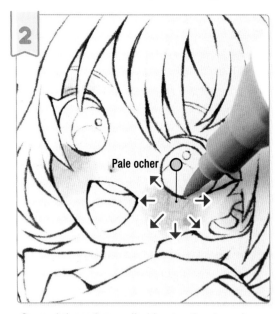

Spread the color applied in step 1 outward using pale ocher.

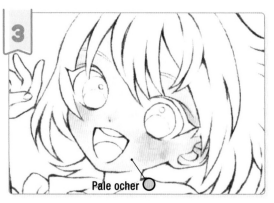

Use pale ocher to color the rest of the face.

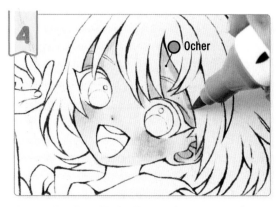

Use ocher to add shadow to the areas under the bangs and inside the ears.

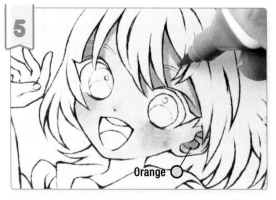

Layer orange on top of the areas colored in step 4 to make the shadows darker.

Coloring the Arms & Legs

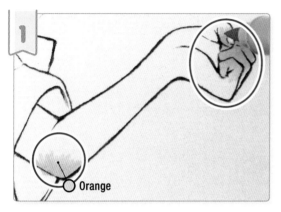

Apply orange to the elbows and fingertips.

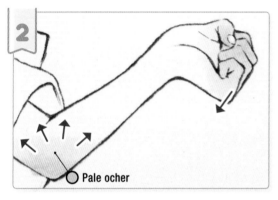

Spread the color applied in step 1 outward using pale ocher.

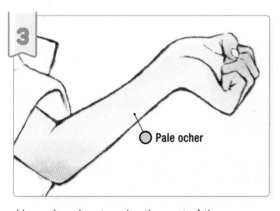

Use pale ocher to color the rest of the arms.

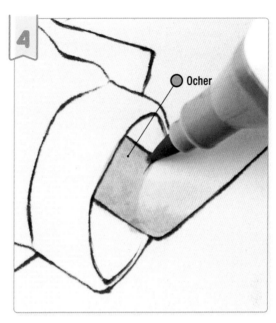

Use ocher to add shadows under the sleeves.

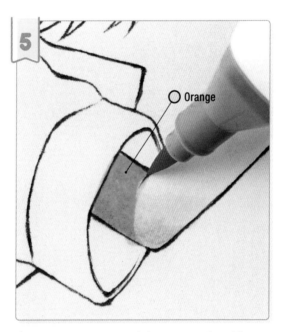

Layer orange on top of the areas colored in step 4 to make the shadows darker.

Color the Legs in the Same Way as the Arms

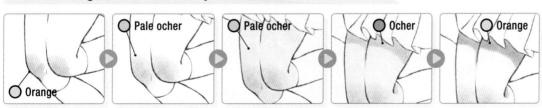

Coloring the Neck & Torso

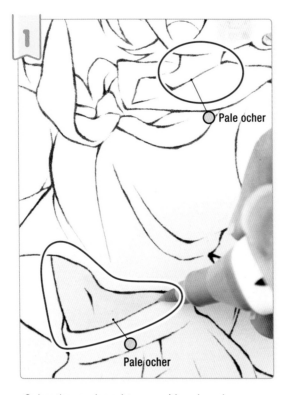

Color the neck and torso with pale ocher.

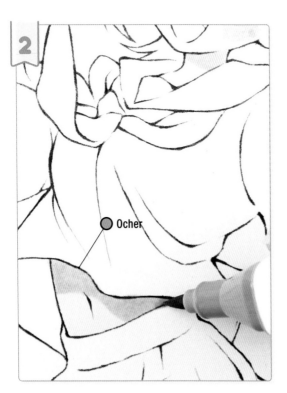

Layer ocher on the top half of the neck and torso to add shadow.

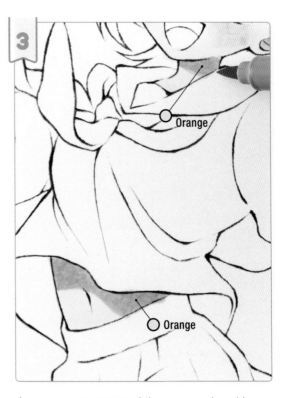

Layer orange on top of the areas colored in step 2 to make the shadows darker.

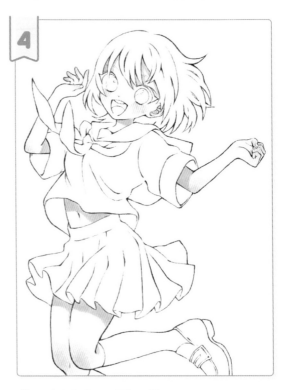

Completed view of the skin.

HOW TO COLOR THE EYES & MOUTH

The key here is to create highlights in the eyes and to leave the teeth white when coloring the mouth.

Coloring the Eyes

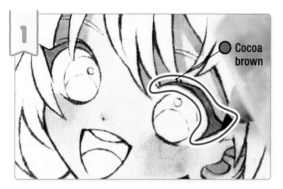

Apply eyeliner using cocoa brown. When coloring fine areas such as this, hold the pen upright and use the tip of the brush.

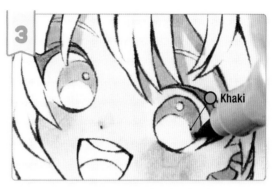

Color the iris (outer circle) with khaki.

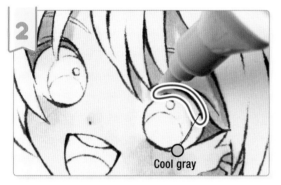

Use cool gray to add shadow to the white of the eye along the upper areas.

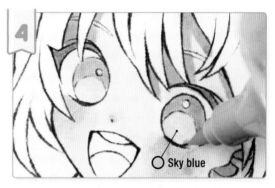

Color the pupil (inner circle) with sky blue.

Coloring the Mouth

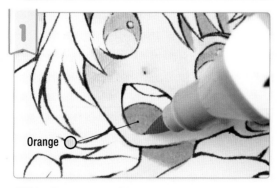

Fill in the tongue with orange.

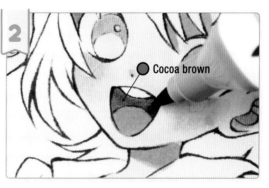

Fill in the inside of the mouth with cocoa brown.

HOW TO COLOR THE HAIR

When coloring hair, run the brush from the tips toward the roots. This will blend the colors beautifully and create movement within the hair.

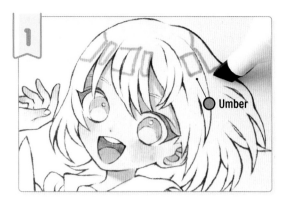

Use umber to outline rectangular highlights around the crown of the head. It's easiest to draw these outlines using the chisel tip.

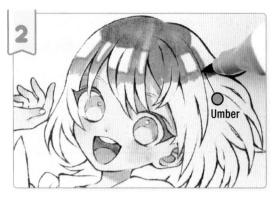

Color the crown of the head umber, taking care to leave the highlights white.

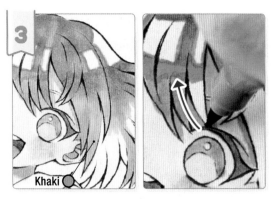

Next, apply khaki to the middle section of the hair, brushing upward to blend the color into the umber from step 2. Repeat steps 2 and 3 as desired to blend the colors.

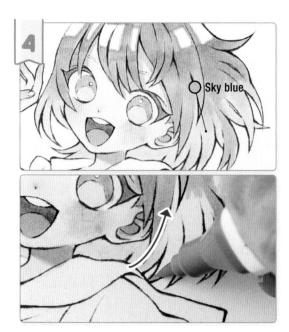

Apply sky blue to the lower section of the hair, brushing upward to blend the color into the khaki from step 3. The sky blue should appear on the areas where the underside of the hair is visible and is used to create shadow.

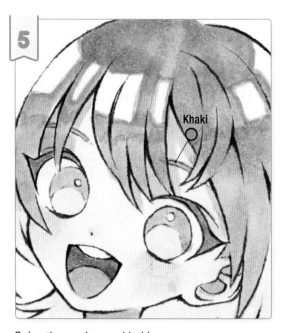

Color the eyebrows khaki.

HOW TO COLOR THE CLOTHES

This character's sailor outfit features lots of whites and blues for a clean, crisp look. Let's learn how to use blending and shadow to create realistic looking clothing.

Coloring the Sleeves & Collar

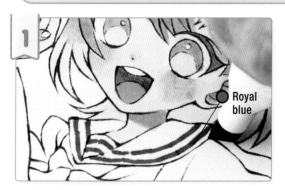

Use royal blue to outline a wide stripe around the edge of the collar that will remain white. It's easiest to draw this outline using the chisel tip.

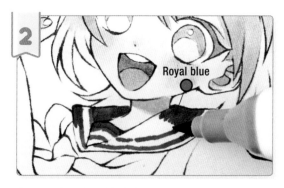

Next, color about half the area above the stripe using royal blue.

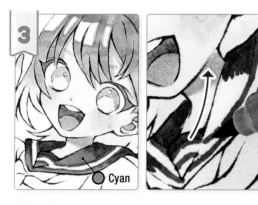

Color the remaining half using cyan, brushing upward to blend the color into the royal blue from step 2. Make sure to color the narrow area below the stripe cyan as well.

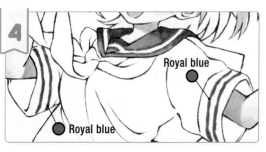

Use royal blue to outline a wide stripe around each sleeve. The stripes will remain white.

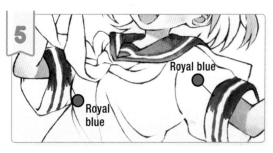

Color about half the area on each side of the stripes using royal blue.

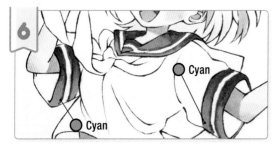

Color the remaining half cyan, brushing upward to blend the color into the royal blue from step 5.

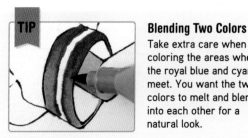

TIP

Blending Two Colors
Take extra care when coloring the areas where the royal blue and cyan meet. You want the two colors to melt and blend into each other for a natural look.

Coloring the Scarf

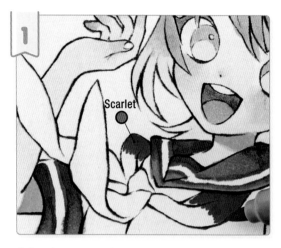

Color the top sections of the scarf with scarlet.

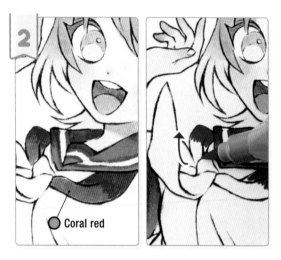

Apply coral red underneath the areas colored in step 1. Use upward brushstrokes to blend the coral red into the scarlet where the two colors overlap.

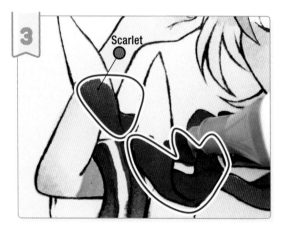

Color the areas circled above with scarlet.

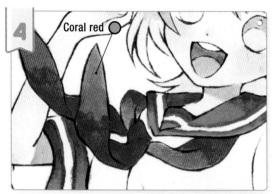

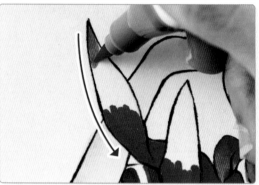

Fill the remaining areas with coral red, brushing from the tips of the scarf to the scarlet areas colored in step 3.

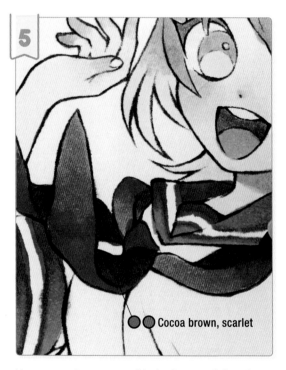

Use cocoa brown to add shadow, and then layer scarlet on top to make the shadows darker.

Coloring the Shirt

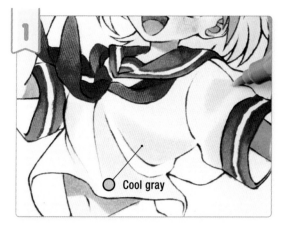

Cool gray

Use cool gray to add shadows to the shirt. You'll need to apply several layers, since a single coat will be too light.

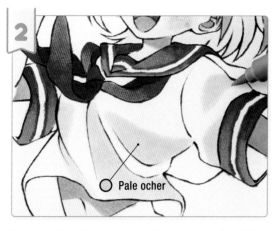

Pale ocher

Layer pale ocher on top of the areas colored in step 1 to make the shadows darker.

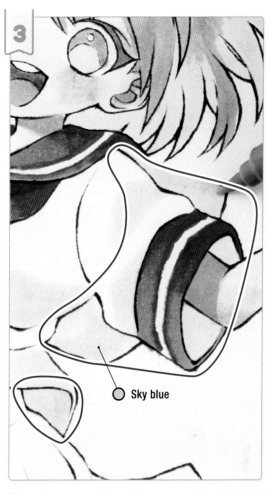

Sky blue

Color the areas where the wrong side of the fabric is visible with sky blue. This includes the wrong side of the collar and inside of the sleeves as well.

Coloring the Skirt

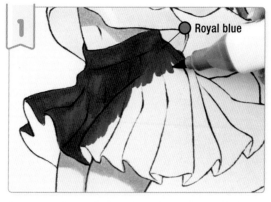

Royal blue

Color the first third of the skirt with royal blue.

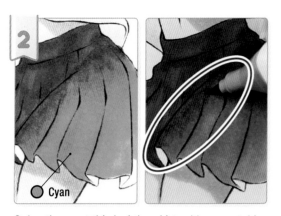

Cyan

Color the next third of the skirt with cyan, taking care to blend the area where the two colors meet.

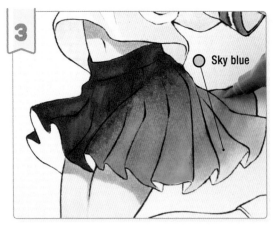

Color the remaining third of the skirt with sky blue, taking care to blend the area where it meets the cyan.

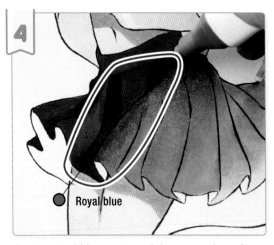

Layer royal blue on top of the area where it overlaps with the cyan. This will create shadow.

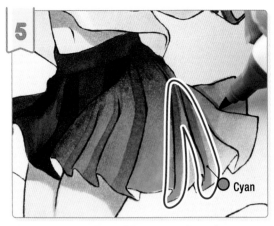

Layer cyan on top of the area where it overlaps with the sky blue to create shadow there as well.

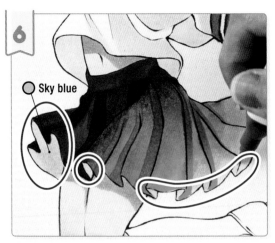

Color the areas where the wrong side of the fabric is visible with sky blue.

Coloring the Socks

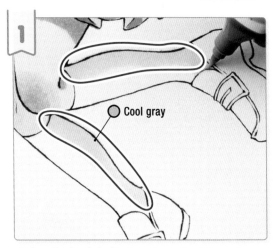

Color the back half of each sock with cool gray.

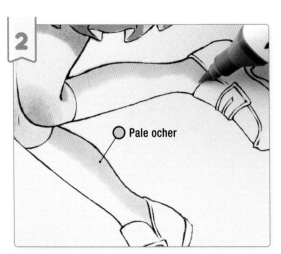

Layer pale ocher on top of the areas colored in step 1.

HOW TO COLOR THE SHOES

When coloring shoes, work from the heel toward the toe, keeping in mind the unique sheen of leather.

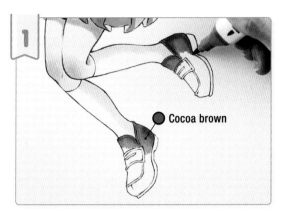

Color the heel with cocoa brown.

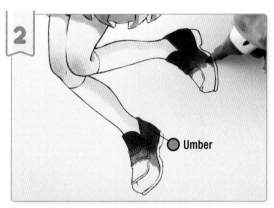

Apply a layer of umber on top, spreading it out to the middle of the shoe.

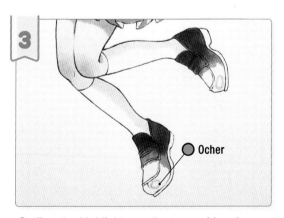

Outline the highlights on the toes with ocher.

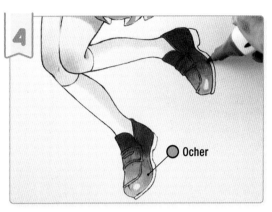

Fill in the toes with ocher, leaving the highlights white.

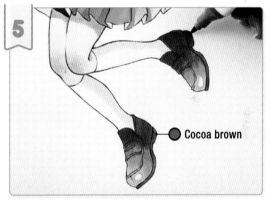

Color the soles with cocoa brown.

FINISHED!

COLOR SCHEME VARIATIONS

Use the practice pages at the back of the book to try out different color schemes!

COLORS USED

- Lavender
- Baby pink
- Pale pink
- Pale blue
- Cocoa brown
- Ocher
- Pale ocher
- Orange

PASTEL

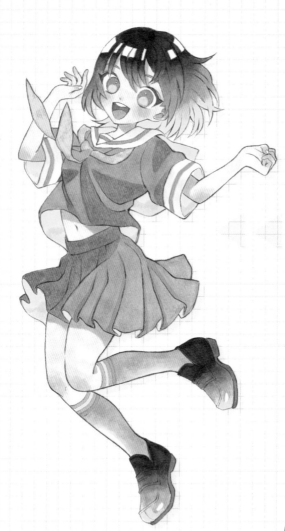

VIBRANT

COLORS USED

- ⬤ Leaf green
- Pale green
- ⬤ Khaki
- ⬤ Dark gray
- ⬤ Ocher
- Orange
- ⬤ Apple green
- Canary yellow
- ⬤ Cocoa brown
- ⬤ Warm gray
- Pale ocher

COLORS USED

- ⬤ Dark gray
- Gray
- ⬤ Warm gray
- ⬤ Cocoa brown
- ⬤ Umber
- ⬤ Lavender
- Lilac
- ⬤ Ocher
- Pale ocher
- Orange

NEUTRAL

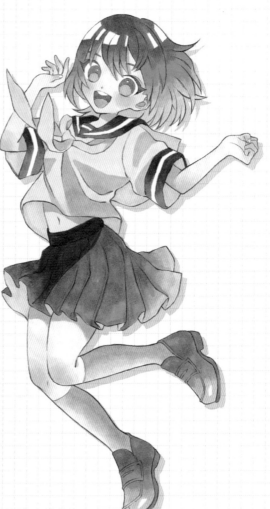

LET'S COLOR A CHARACTER IN A POP IDOL OUTFIT

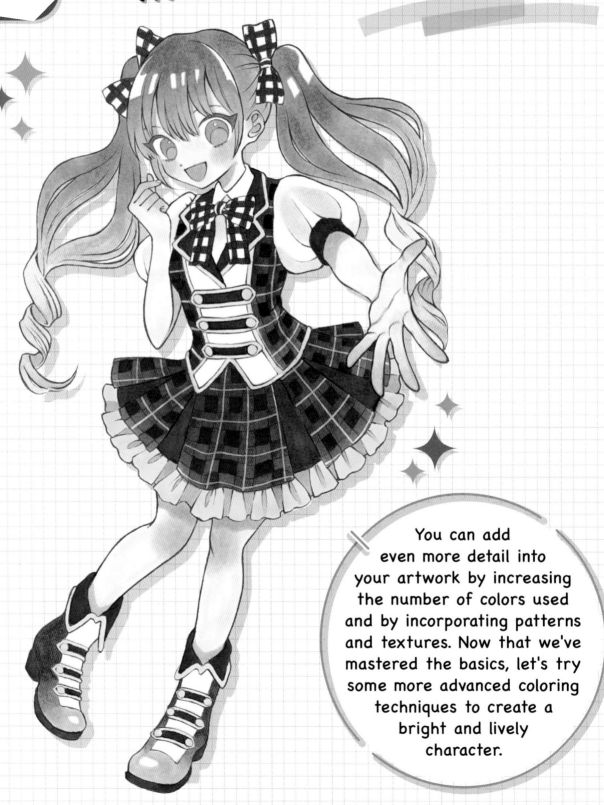

You can add even more detail into your artwork by increasing the number of colors used and by incorporating patterns and textures. Now that we've mastered the basics, let's try some more advanced coloring techniques to create a bright and lively character.

COLOR PLANNING

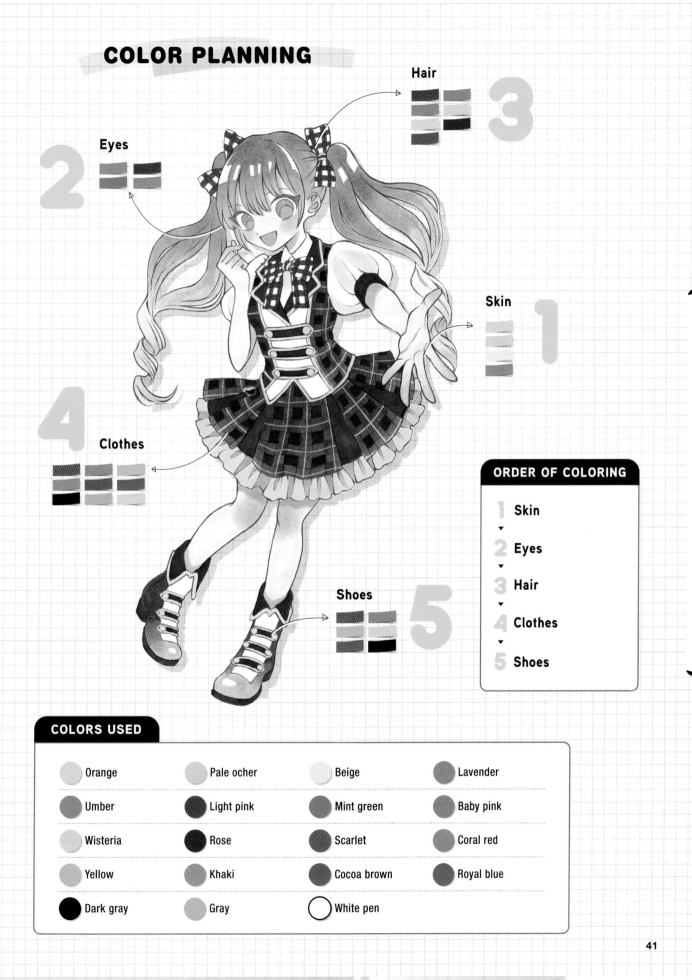

Hair 3

Eyes 2

Skin 1

Clothes 4

Shoes 5

ORDER OF COLORING

1 Skin
▾
2 Eyes
▾
3 Hair
▾
4 Clothes
▾
5 Shoes

COLORS USED

Orange	Pale ocher	Beige	Lavender
Umber	Light pink	Mint green	Baby pink
Wisteria	Rose	Scarlet	Coral red
Yellow	Khaki	Cocoa brown	Royal blue
Dark gray	Gray	White pen	

HOW TO COLOR THE SKIN

For this drawing, we'll use the same base colors for the skin as in Chapter 2, but incorporate lavender to create bluish purple shadows.

Coloring the Face

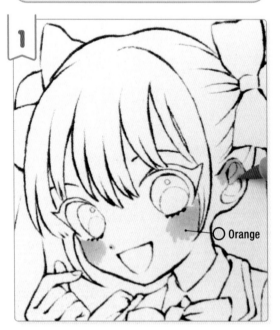

Apply orange to areas where you want to create a rosy, flushed appearance, such as the cheeks and ears.

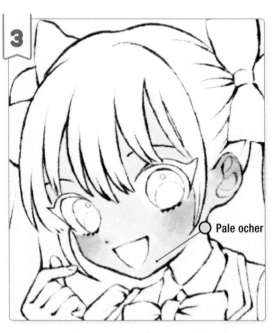

Use pale ocher to color the rest of the face. This will serve as the base color for the skin.

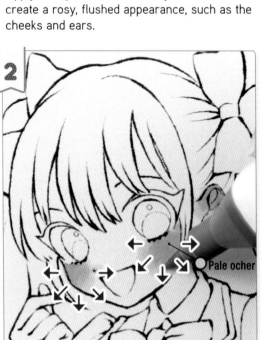

Spread the color applied in step 1 outward using pale ocher.

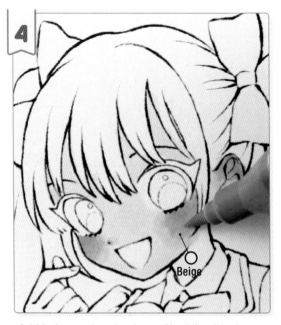

Add beige to the cheeks as if adding blush.

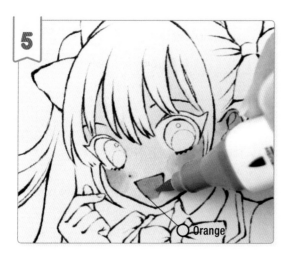

Fill in the mouth with orange.

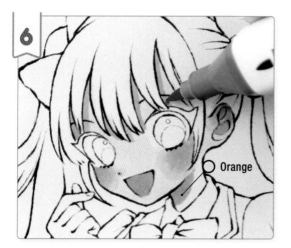

Use orange to add shadow to the areas under the bangs, inside the ears, and under the chin.

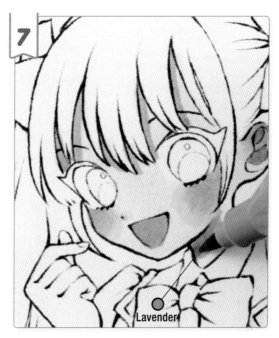

Layer lavender on top of the areas colored in step 6 to make the shadows darker.

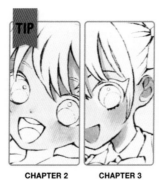

CHAPTER 2 CHAPTER 3

Selecting a Shadow Color

The same skin base colors were used for the characters in both Chapters 2 and 3. But by using a blue color for the shadows, the skin of the character here in Chapter 3 has a more delicate, transparent look.

Coloring the Arms & Legs

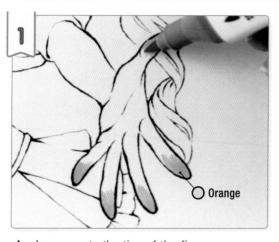

Apply orange to the tips of the fingers.

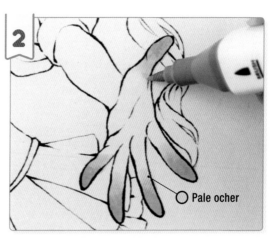

Spread the color applied in step 1 outward using pale ocher.

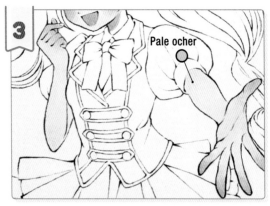

Use pale ocher to color the rest of the arms.

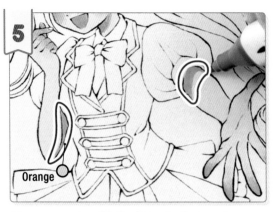

Use orange to add shadows to the upper arms.

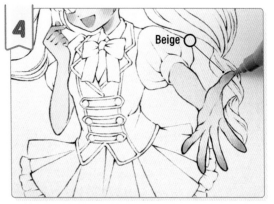

Layer beige on top of the orange applied to the fingertips in step 1.

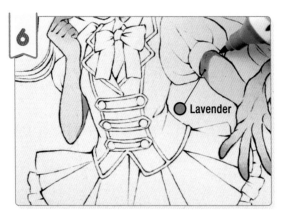

Layer lavender on top of the areas colored in step 5 to make the shadows darker.

Color the Legs in the Same Way as the Arms

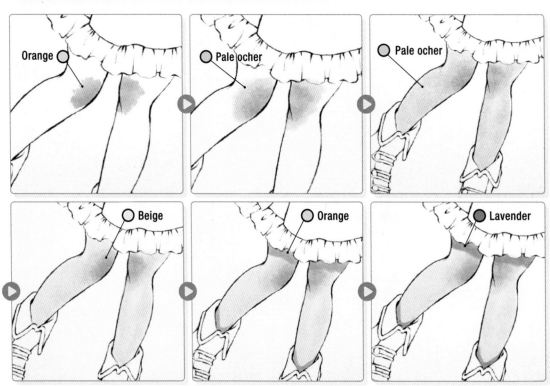

HOW TO COLOR THE EYES

When applying eyeliner to the lids, the key is to hold the marker upright and use the very tip of the brush.

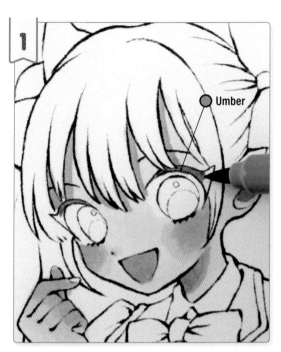

Use umber to apply eyeliner to the lids, leaving the outer corners white.

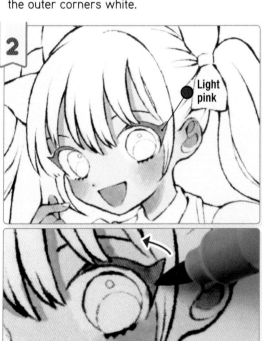

Apply light pink to the outer corners that were left white in step 1. Start at the outer corners and brush inward.

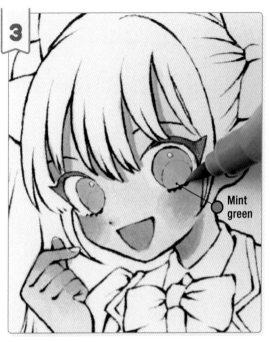

Fill the irises and pupils with mint green, leaving the highlights white.

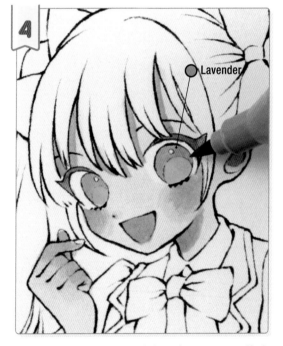

Layer lavender on top of the mint green applied to the irises (outer circles) in step 3.

HOW TO COLOR THE HAIR

Express movement within the hair by blending multiple colors. Carrying the skin color through to the bangs will give them a light, slightly transparent look.

Coloring the Hair

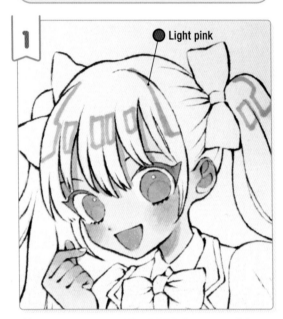

1 ● Light pink

Use light pink to outline highlights around the crown of the head.

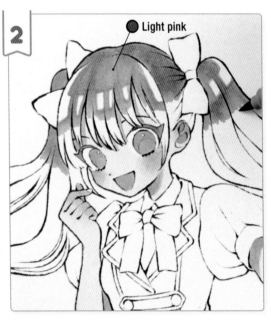

2 ● Light pink

Color the crown of the head light pink, taking care to leave the highlights white.

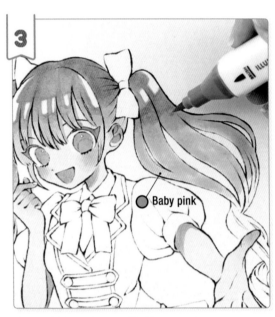

3 ● Baby pink

Spread the color applied in step 2 downward using baby pink.

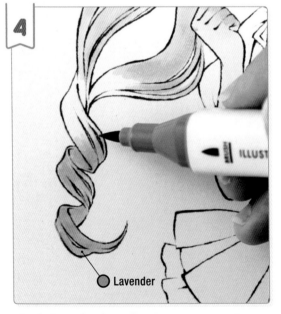

4 ● Lavender

Apply lavender from the tips of the pigtails, brushing upward. Leave the mid-sections of the pigtails white for now.

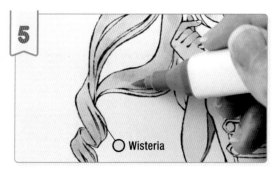

5

○ Wisteria

Next, spread the color applied in step 4 upward using wisteria. Fill in the mid-sections of the pigtails, blending the lavender into the baby pink.

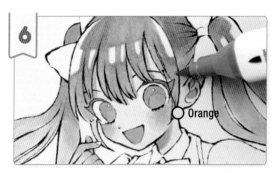

6

○ Orange

Add orange to the bangs, starting at the bottom and brushing upward.

Coloring the Bows

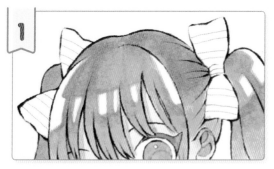

1

Use a pencil to draw guidelines for the horizontal stripes.

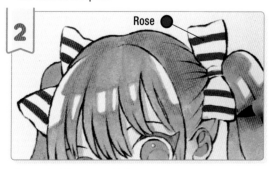

2

Rose ●

Color inside the guidelines using rose.

3

Use a pencil to draw guidelines for the vertical stripes to complete the plaid pattern.

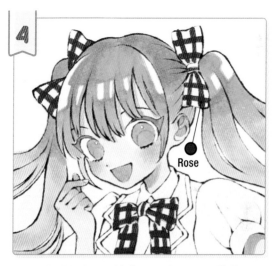

4

● Rose

Color inside the guidelines using rose. Follow the same process used in steps 1-3 to color a plaid pattern on the bow at the neck as well.

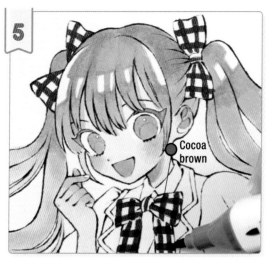

5

○ Cocoa brown

Layer cocoa brown on top of the areas where the horizontal and vertical lines intersect.

HOW TO COLOR THE CLOTHES

For this more advanced character, we'll express texture by adding a three-dimensional plaid pattern to the clothing, as well as ruffles and gathers.

Coloring the Collar, Buttons & Shirt

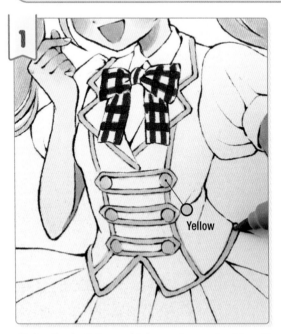

Color the buttons and trim on the vest with yellow.

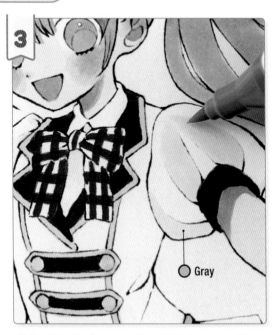

Color the shadows on the shirt sleeves with gray.

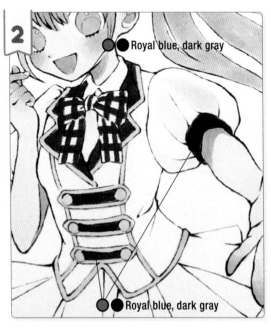

Color the collar, cuffs, and button plackets with royal blue and dark gray. Layering the two colors will produce a navy blue shade.

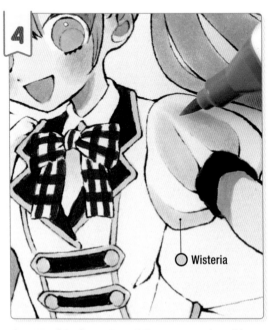

Layer wisteria on top of the areas colored in step 3 to make the shadows darker.

Coloring the Vest

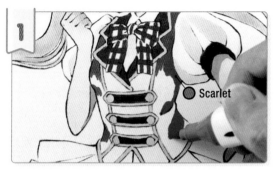

Color the vest scarlet, leaving some areas at the center white, including the entire center panel of the vest.

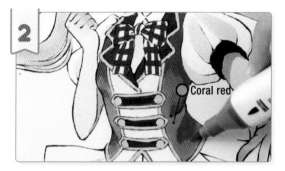

Apply coral red to the areas left white in step 1, blending the color with the scarlet. Take care to leave the center panel of the vest white.

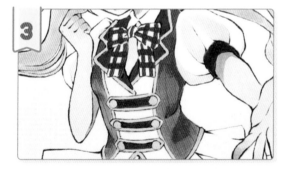

Use a pencil to draw guidelines for the vertical stripes.

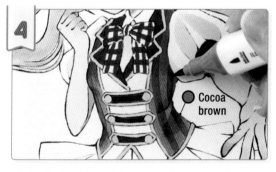

Color inside the guidelines using cocoa brown.

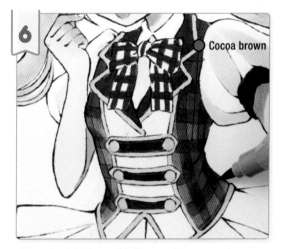

Use a pencil to draw guidelines for the horizontal stripes to complete the plaid pattern.

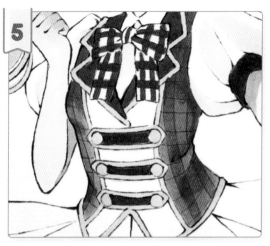

Color inside the guidelines using cocoa brown.

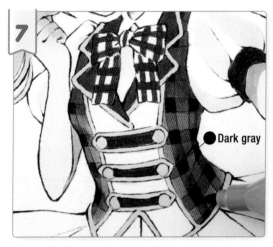

Layer dark gray on top of the areas where the vertical and horizontal stripes intersect. This will give the plaid a classic look.

Coloring the Skirt

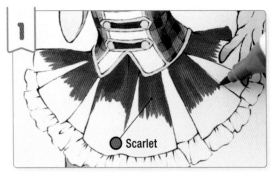

1 Scarlet

Color the top half of the skirt with scarlet, leaving every other pleat white.

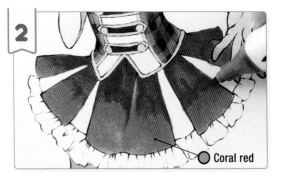

2 Coral red

Spread the color applied in step 1 outward using coral red.

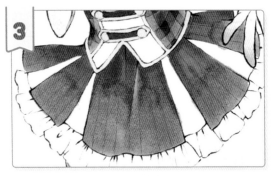

3

Use a pencil to draw guidelines for the vertical stripes.

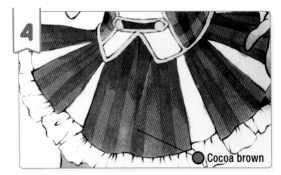

4 Cocoa brown

Color inside the guidelines using cocoa brown.

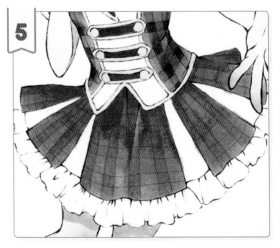

5

Use a pencil to draw guidelines for the horizontal stripes to complete the plaid pattern.

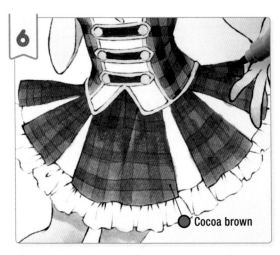

6 Cocoa brown

Color inside the guidelines using cocoa brown.

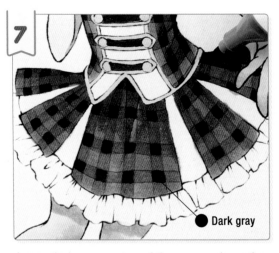

7 Dark gray

Layer dark gray on top of the areas where the vertical and horizontal stripes intersect. This will give the plaid a classic look.

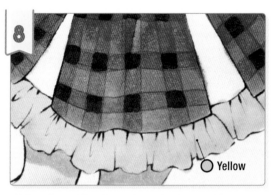

Color the ruffle along the skirt hem with yellow.

○ Yellow

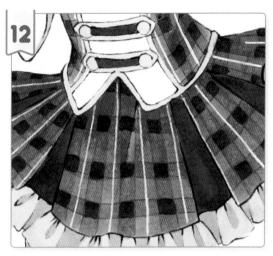

Use white pen to draw vertical lines that overlap the lighter sections of the plaid pattern on both the skirt and vest.

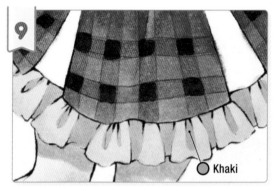

Color the shadows on the ruffle with khaki.

○ Khaki

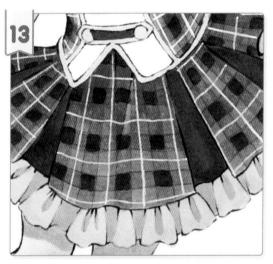

Next, follow the same process to draw horizontal lines.

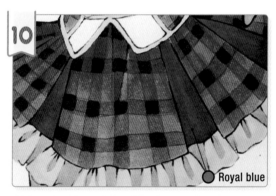

Color the pleats left white in step 1 with royal blue.

○ Royal blue

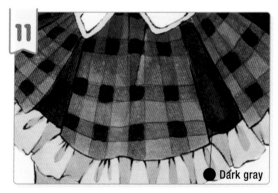

Layer dark gray on top of the areas colored in step 10.

● Dark gray

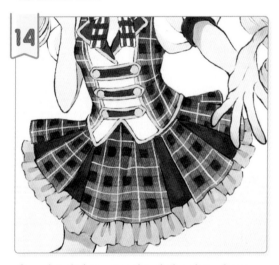

Completed view once the clothes have been colored.

HOW TO COLOR THE SHOES

When coloring this character's shoes, we'll use similar colors as the clothes. The key is to add highlights to the toes to express the differences in texture between the fabric and leather.

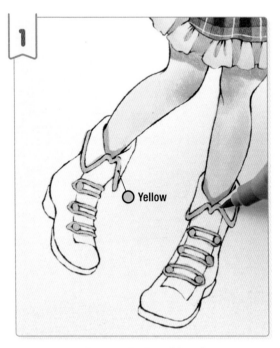

Color the buttons and trim with yellow.

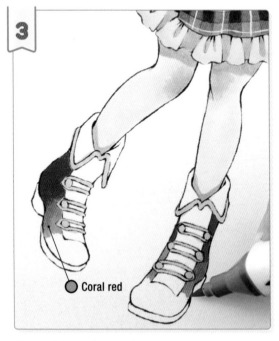

Color slightly less than half the shoes with scarlet.

Spread the color applied in step 2 outward using coral red.

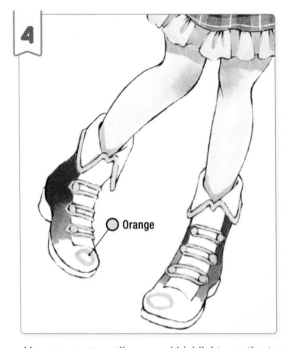

Use orange to outline round highlights on the toes.

5

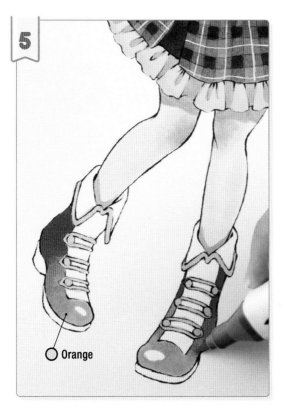

Orange

Color the toes orange, taking care to leave the highlights white.

6

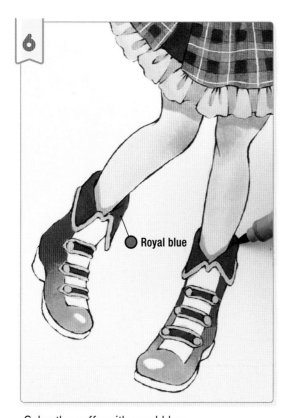

Royal blue

Color the cuffs with royal blue.

7

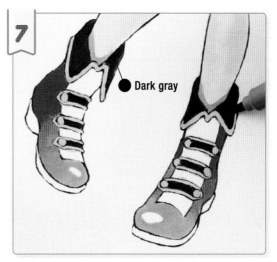

Dark gray

Layer dark gray on top of the areas colored in step 6.

8

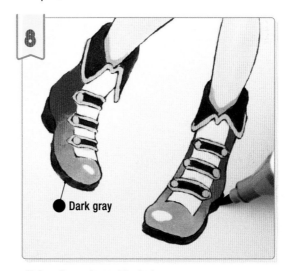

Dark gray

Color the soles with dark gray.

FINISHED!

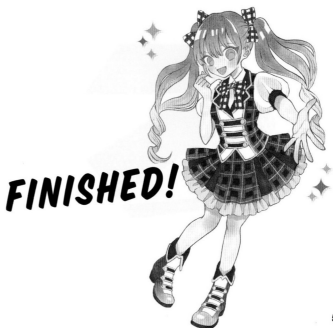

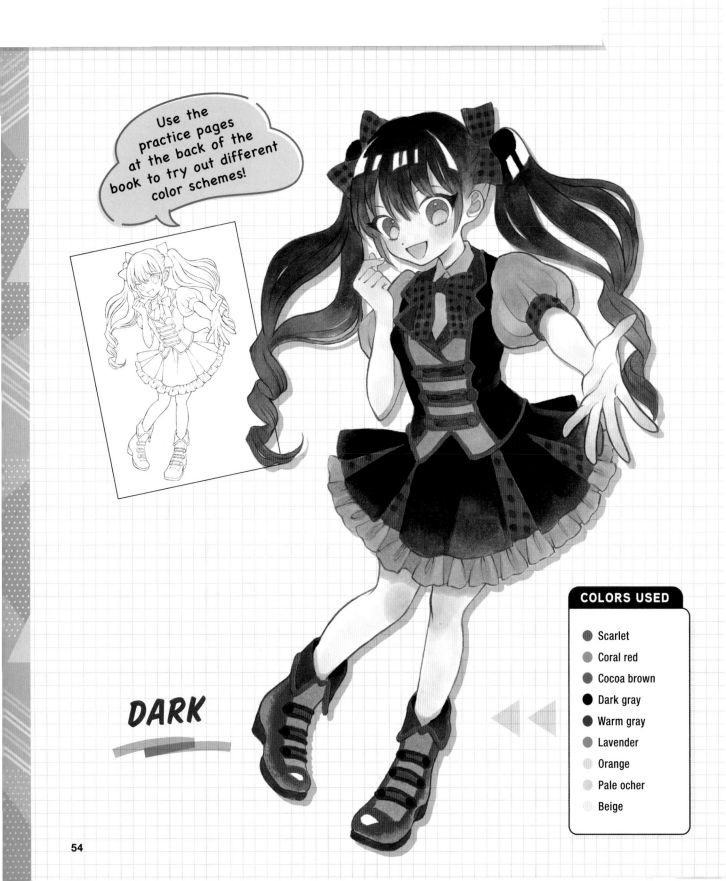

Use the practice pages at the back of the book to try out different color schemes!

DARK

COLORS USED

- Scarlet
- Coral red
- Cocoa brown
- Dark gray
- Warm gray
- Lavender
- Orange
- Pale ocher
- Beige

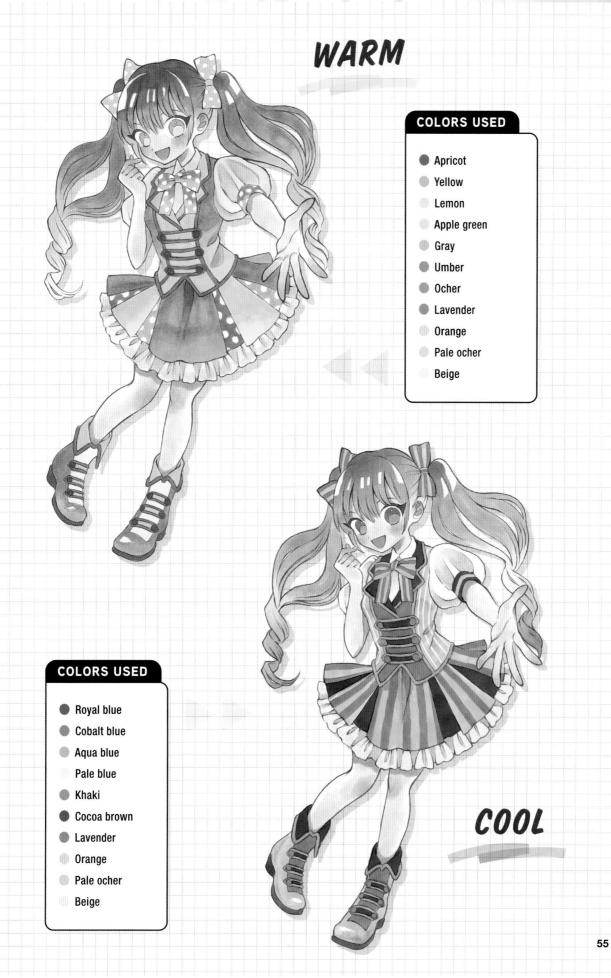

WARM

COLORS USED

- Apricot
- Yellow
- Lemon
- Apple green
- Gray
- Umber
- Ocher
- Lavender
- Orange
- Pale ocher
- Beige

COLORS USED

- Royal blue
- Cobalt blue
- Aqua blue
- Pale blue
- Khaki
- Cocoa brown
- Lavender
- Orange
- Pale ocher
- Beige

COOL

LET'S COLOR EVERYDAY OBJECTS

In addition to drawing characters, manga also involves drawing objects that are part of everyday life. It's important to think about color choices for these objects so they have a realistic appearance, but also complement the color scheme of your characters.

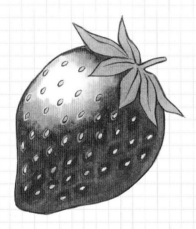

STRAWBERRY ▶ *Coloring instructions on page 58*

The goal is to create a three-dimensional effect with lavender shadows and white highlights.

COLORS USED

- Yellow
- Scarlet
- Orange
- Lemon
- Lavender
- Leaf green
- ○ White pen

ORANGE ▶ *Coloring instructions on page 59*

Express the texture of the orange segments by blending apricot into yellow, and then use white pen to add shiny highlights.

COLORS USED

- Apricot
- Lemon
- Yellow
- ○ White pen

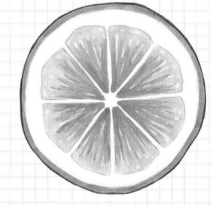

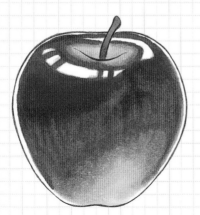

APPLE ▶ *Coloring instructions on page 60*

Emphasize the sheen of the apple skin by darkening the color around the highlights.

COLORS USED

- Scarlet
- Apricot
- Yellow
- Umber
- Cocoa brown
- Apple green

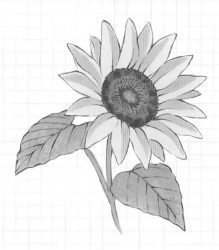

SUNFLOWER ▶ *Coloring instructions on page 61*

Shadows on the petals and umber dots at the center accentuate the texture of the sunflower.

COLORS USED

- Canary yellow
- Yellow
- Orange
- Apricot
- Umber
- Apple green
- Leaf green

TULIP ▶ *Coloring instructions on page 62*

Adding shadows and streaks with lavender enhances the texture of the leaves.

COLORS USED

- Coral red
- Baby pink
- Apple green
- Lemon
- Pale pink
- Leaf green
- Yellow
- Lavender

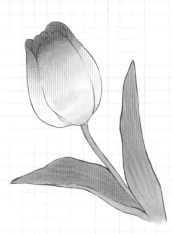

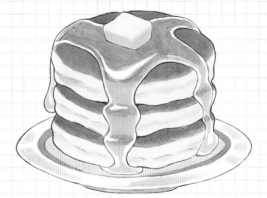

PANCAKES ▶ *Coloring instructions on page 63*

Combine apricot and yellow to express the transparency of the maple syrup.

COLORS USED

- Umber
- Apricot
- Lemon
- Yellow
- Pale ocher
- Gray
- Warm gray

SODA ▶ *Coloring instructions on page 64*

Mix cyan and leaf green to capture the vibrant color of this cream soda that is a popular treat in Japan.

COLORS USED

- Yellow
- Lemon
- Cyan
- Leaf green
- Apple green
- Scarlet
- Apricot
- Gray
- Warm gray
- Dark gray
- White pen

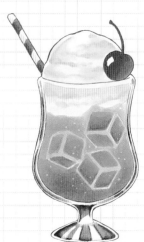

Coloring a Strawberry

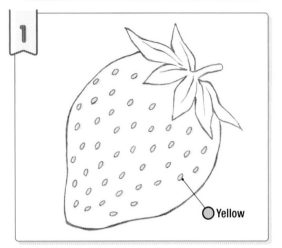

○ Yellow

Color the seeds with yellow.

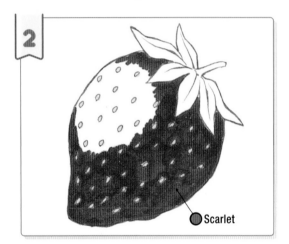

◐ Scarlet

Color the strawberry scarlet, leaving the seeds yellow. Leave a large circular area at the top white. This will be a highlight.

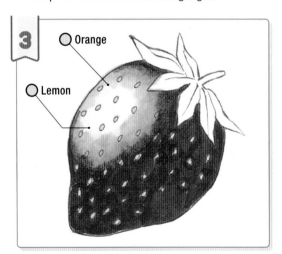

○ Orange

○ Lemon

Spread the color applied in step 2 outward using orange and lemon. Leave the center of the highlight white.

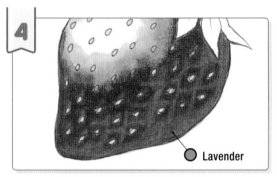

● Lavender

Use lavender to add shadows to the areas where light does not hit.

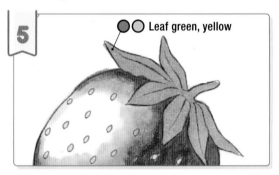

●○ Leaf green, yellow

Color the leaves with leaf green. Next, layer yellow on top.

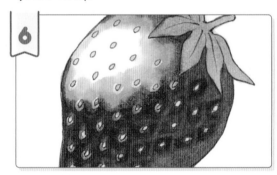

Use a white pen to outline the seeds where the markers have bled onto the yellow. This will also create highlights.

FINISHED!

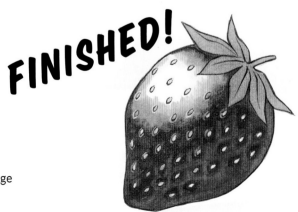

Coloring an Orange

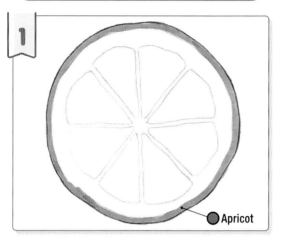

Color a thin ring of apricot around the perimeter of the circle.

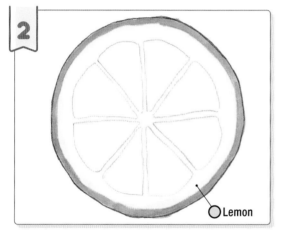

Add a thin ring of lemon inside the ring of apricot from step 1, blending the two colors together where they meet.

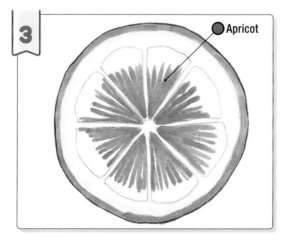

Fill each segment with apricot brushstrokes that start at the center and radiate outward. The brushstrokes should extend about ¾ of the way to the edge.

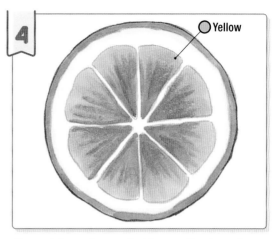

Spread the color applied in step 3 outward using yellow.

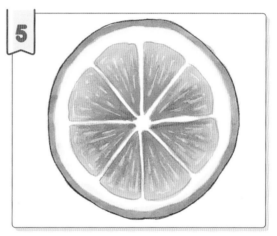

Use a white pen to add highlights to each segment. The highlights will help convey the juicy texture.

FINISHED!

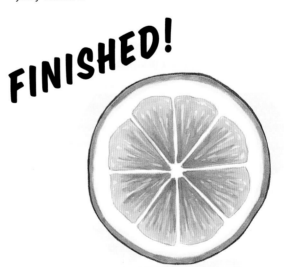

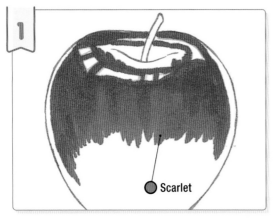

Scarlet

Color the top half of the apple with scarlet, leaving some areas at the top and edges white for highlights.

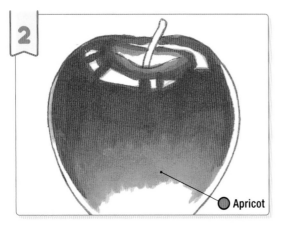

Apricot

Spread the color applied in step 1 downward using apricot.

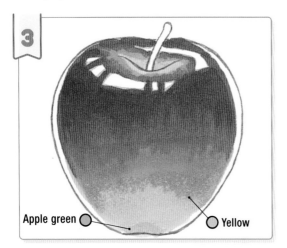

Apple green ○ ○ **Yellow**

Color the bottom of the apple yellow, blending it with the apricot from step 2. Layer apple green on top of the yellow at the very base of the apple.

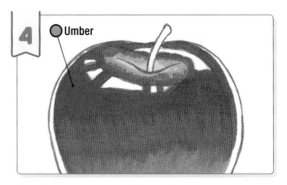

Umber

Apply umber around the perimeter of the highlights to make them stand out.

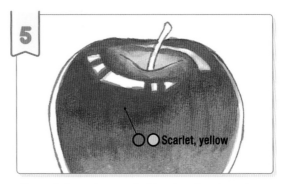

○○**Scarlet, yellow**

Spread the color applied in step 4 outward using scarlet. Next, blend in some yellow.

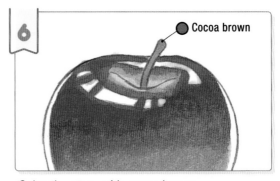

● **Cocoa brown**

Color the stem with cocoa brown.

FINISHED!

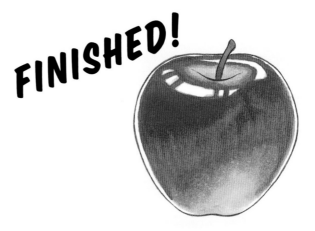

Coloring a Sunflower

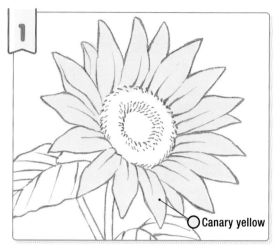

○ Canary yellow

Color the petals with canary yellow.

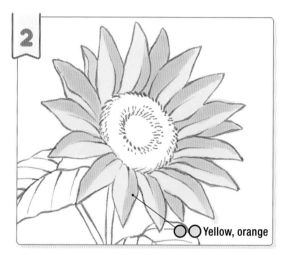

○○ Yellow, orange

Add shadows to the petals using yellow, and then layer orange on top.

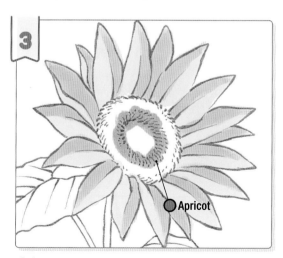

● Apricot

Color an apricot ring at the center of the sunflower.

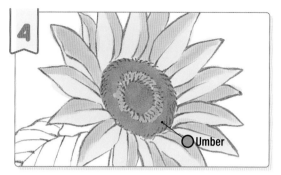

○ Umber

Fill in the remaining area at the center using umber.

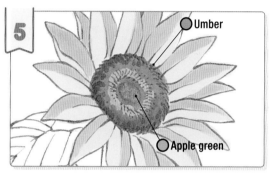

○ Umber

● Apple green

Add an apple green circle to the very center. Add umber strokes to the perimeter of the sunflower center to capture the fuzzy texture.

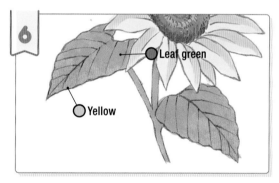

○ Leaf green

○ Yellow

Color the leaves and stems with leaf green. Next, layer yellow on top of the leaf tips.

FINISHED!

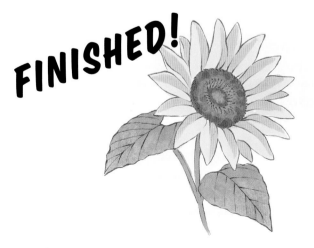

Coloring a Tulip

1

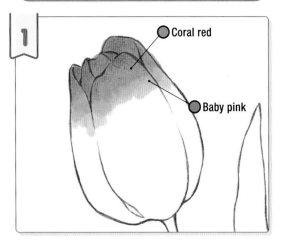

Coral red

Baby pink

Color the tips of the petals with coral red.
Spread the color downward using baby pink,
so about $\frac{1}{3}$ of the flower is colored.

2

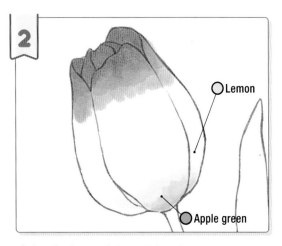

Lemon

Apple green

Color the base of the petals with apple green.
Spread the color upward using lemon.

3

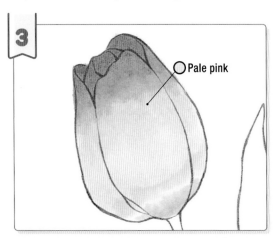

Pale pink

Color the center of the petals with pale pink,
blending the colors together at the top and
bottom and filling the remaining white space.

4

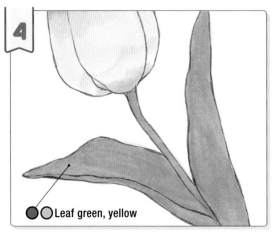

Leaf green, yellow

Color the stem and leaves with leaf green.
Next, layer yellow on top.

5

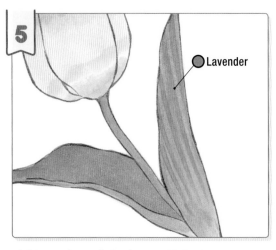

Lavender

Add streaks and shadows with leaf green.
Layer lavender on top using long brushstrokes.

FINISHED!

Coloring Pancakes

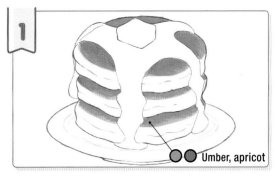

Color the top of each pancake with umber.
Next, apply a layer of apricot on top.

Umber, apricot

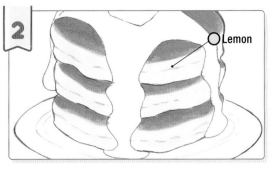

Color the sides of each pancake with lemon.

Lemon

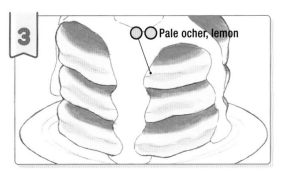

Add shadows to the sides using pale ocher.
Layer another coat of lemon on top to darken
the shadows.

Pale ocher, lemon

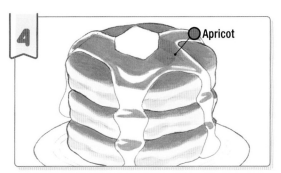

Color the top facing surfaces of the maple
syrup with apricot. Take care to leave some
areas white for the highlights.

Apricot

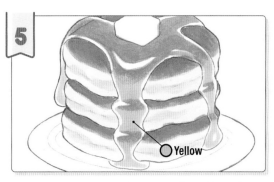

Color the syrup running down the sides of the
pancakes with yellow, blending it into the color
applied in step 4.

Yellow

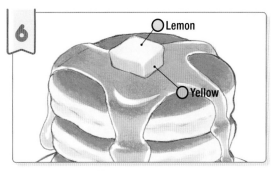

Color the pat of butter with lemon. Layer
yellow along the sides of the butter only to
make these edges darker.

Lemon

Yellow

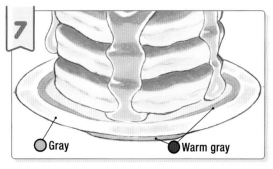

Color the plate with gray, leaving some areas white
for highlights. Add shadows using warm gray.

Gray

Warm gray

FINISHED!

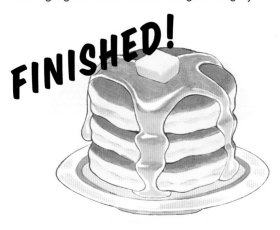

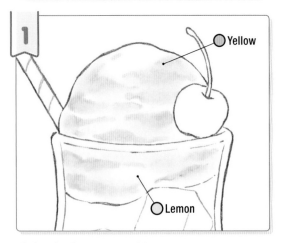

Color the ice cream with yellow, leaving some areas white for highlights. Add streaks of lemon on top of the yellow, blending to create shadows.

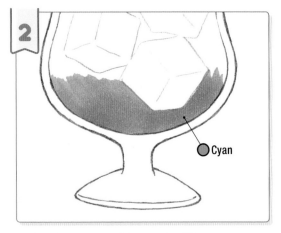

Color the bottom of the soda with cyan.

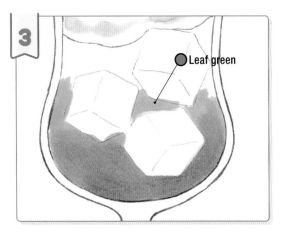

Layer leaf green on top of the color applied in step 2, spreading it upward to the middle of the soda.

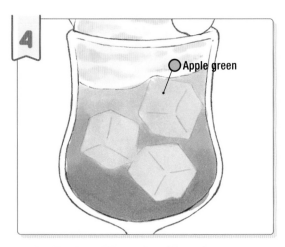

Color the top of the soda with apple green, blending it into the leaf green applied in step 3. Color the ice cubes apple green as well.

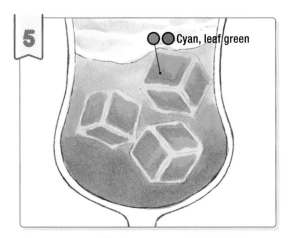

Layer cyan and leaf green on top of the ice cubes, leaving the edges uncolored.

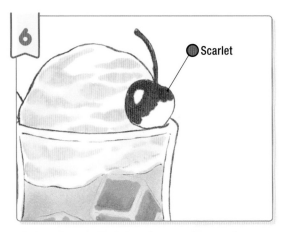

Color about half of the cherry with scarlet, leaving a white highlight.

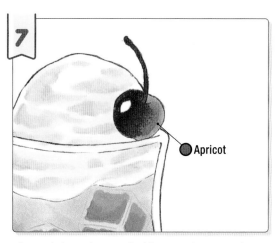

7

Spread the color applied in step 6 outward using apricot to fill in the rest of the cherry (except the highlight).

Apricot

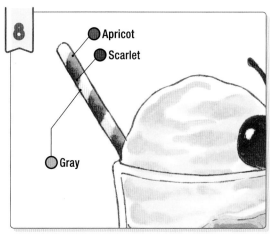

8

Apricot
Scarlet
Gray

Use gray to color the white stripes on the straw. To color the red stripes, fill the bottom half of each stripe with scarlet. Next, spread the color out using apricot to fill the other half of each stripe.

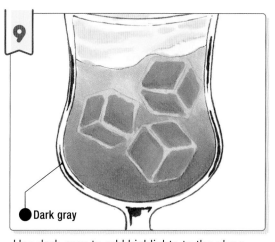

9

Dark gray

Use dark gray to add highlights to the glass.

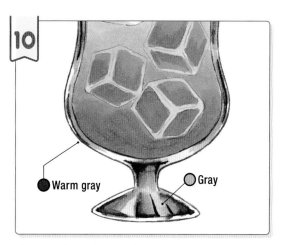

10

Warm gray
Gray

Spread the color applied in step 9 outward using warm gray. Color the entire glass with gray.

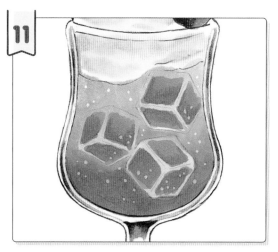

11

Use a white pen to add dots to the soda for bubbles and white highlights to the glass.

FINISHED!

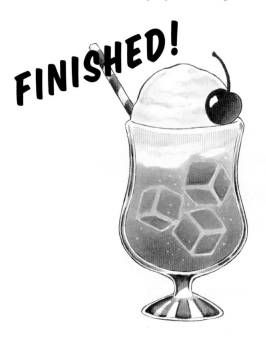

These two illustrations
from manga artist Karin
were created with
the 36 alcohol marker
colors used throughout
this book.

COLORS USED

- Coral red
- Scarlet
- Apricot
- Orange
- Yellow
- Canary yellow
- Lemon
- Umber
- Ocher
- Pale ocher
- Khaki
- Gray
- Cool gray
- Wisteria
- Pale pink
- Lavender
- Sky blue
- Aqua blue
- Pale blue
- Mint green
- Leaf green
- Apple green
- Cocoa brown
- Dark gray

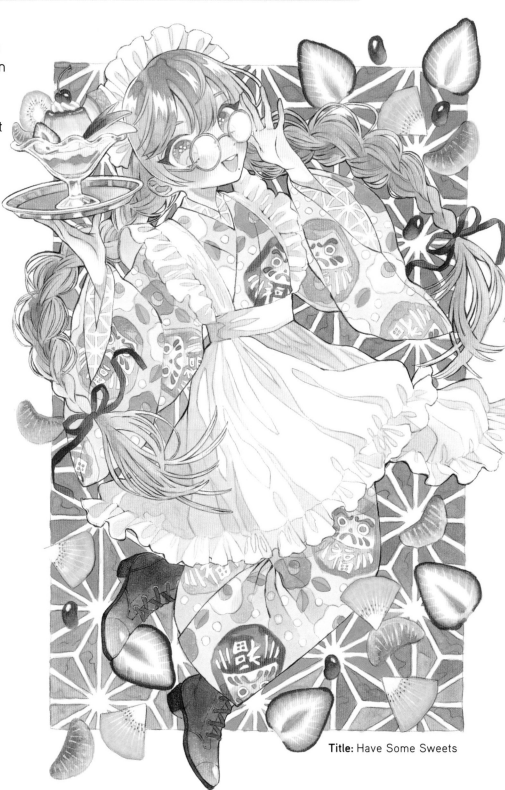

Title: Have Some Sweets

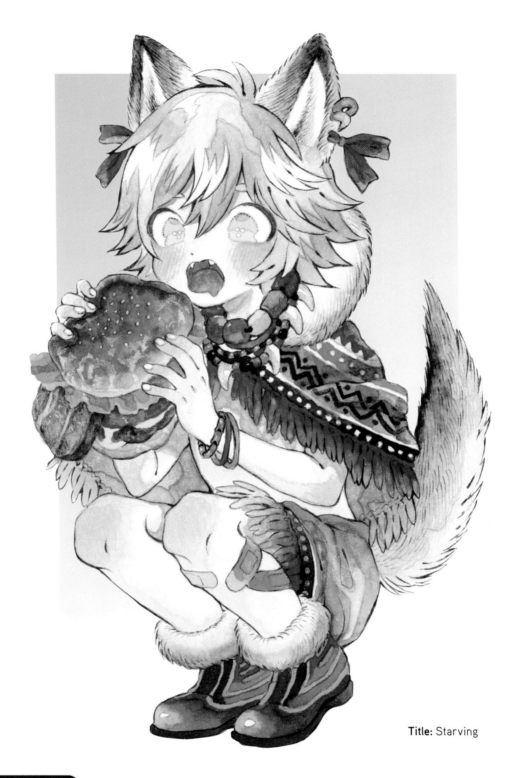

Title: Starving

Here are some additional works by the author exploring a range of color schemes created with alcohol markers.

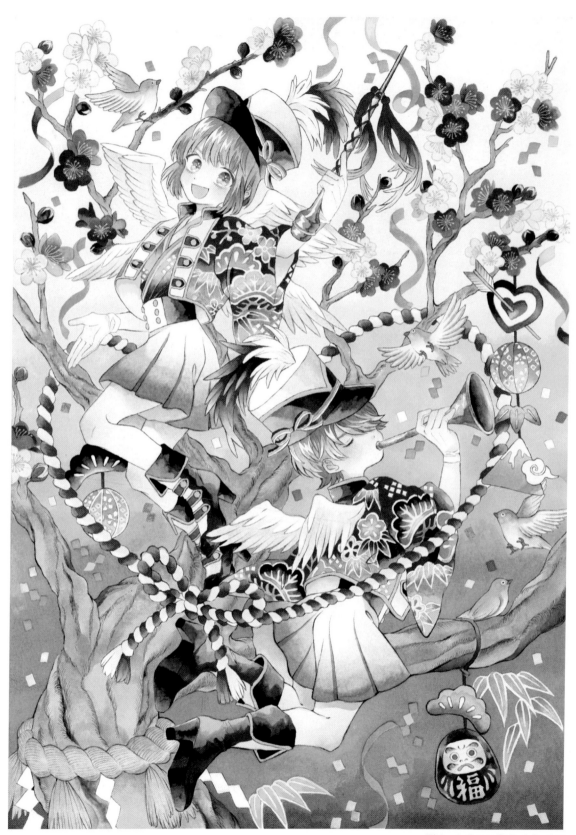

Title: A Song Called Spring

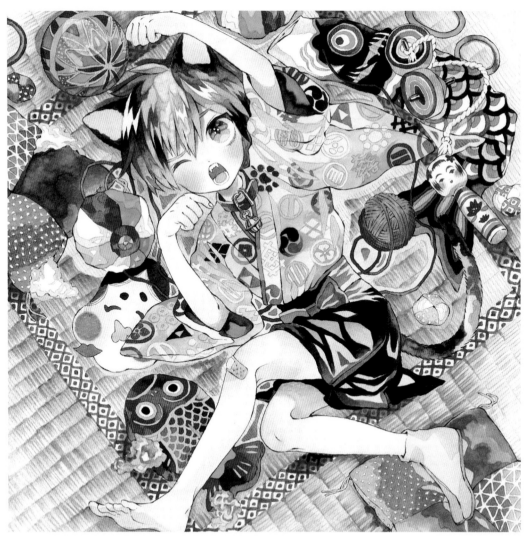

Title:
Capricious
Calico Cat

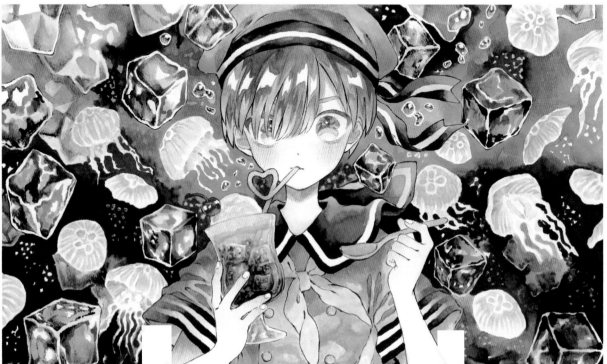

Title: Blue

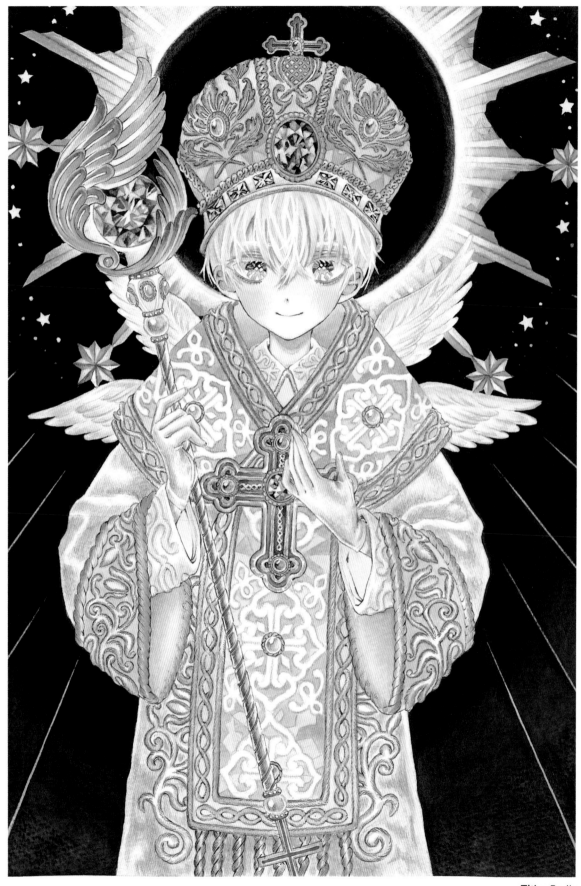

Title: Smile

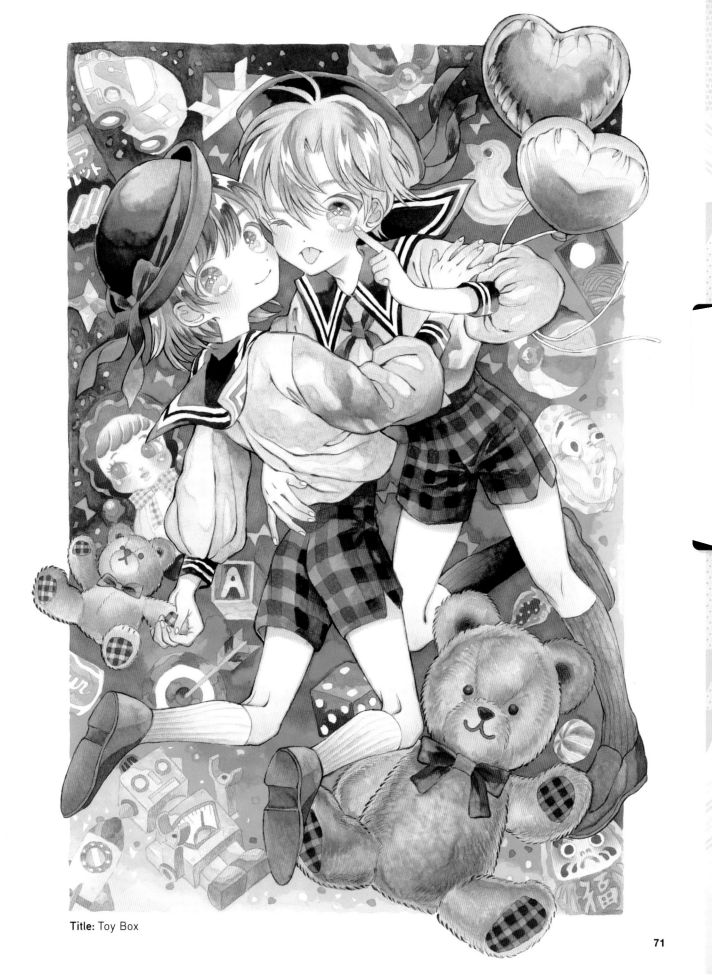

Title: Toy Box

ALCOHOL MARKER COLORING PRACTICE PAGES

The following images are printed on a heavier weight paper, designed to be colored with alcohol markers. Before coloring, cut each page out along the dotted line and layer a piece of scrap paper underneath to prevent any marker bleed through from damaging your work surface or the other illustrations in the book.

Two copies of each illustration are included so you can experiment with different color schemes. You can also photocopy or trace the black and white illustrations for additional practice.

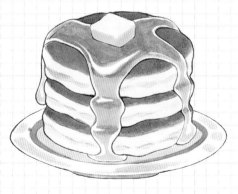

Cut here